Once Upon A Fishbowl

THE STORY OF A BLUE FISH

Written and Illustrated by
ARIA FAFAT

9 789811 188176

Once Upon A Fishbowl

THE STORY OF A BLUE FISH

Written and Illustrated by
ARIA FAFAT

WALKING STICK PUBLICATION
Copyright ©Aria Fafat, 2018
ISBN-13: 978-981-11-8817-6
Published by Walking Stick Publication, Singapore

Author Contact:
Email : priceydoc@yahoo.com
Amazon : www.amazon.com/author/ariafafat

About The Book:
Author : Aria Fafat
Illustrator : Aria Fafat
Cover Design : Vijay Fafat
Cover Layout : Abhishek Tiwari
Book Layout : Vijay Fafat
 Abhishek Tiwari
Design Website : www.creativekindles.com

First Printing : October, 2018

"

I am no longer accepting things I cannot change. I am changing the things I cannot accept.

"

~ Angela Y. Davis

Contents

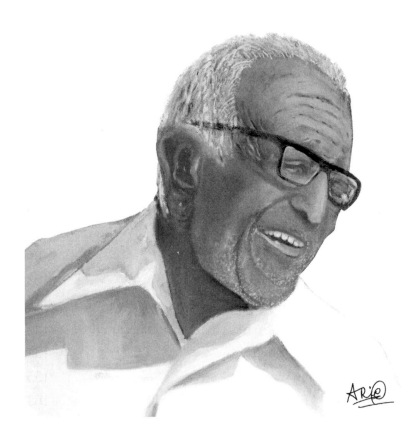

Shri Daoudas Balkisandas Fafat
(August 16, 1935 - June 15, 2018)

Original oil painting by Aria Fafat

Dedication

My Dear Babuji,

Your kind and ancient smile remains with me.
Your hand blessing me every time you patted my head remains with me.
Your constant banter, calling me a little monkey *("baandra")*, remains with me.
Your infinitely loving thought, *"You are my raja beti (princess)"*, remains with me.

You have left this world, but your presence is etched in my mind.

I miss you.

I dedicate this book to you, old man. You were the "big *baandra*" who will always remain in my heart.

In memory of my grandfather,

Shri **Daoudas Balkisandas Fafat**.

Acknowledgements

There is an African proverb: It takes a village to raise a child. I did not realize how true it was till I sat back to reflect on all the people who have helped me write this book. If my name is in this movie, it is because of you who are the make-up artists, cinematographers, directors, hairdressers and camera crew who made a short fifth grade notebook-scrawled story into what you are holding right now, and you deserve to be part of this book!

Firstly, **my mom, Priya**. She is my closest friend and my fiercest critic. She smothers me with her love and infuriates me with her exacting standards. Without her, I would be lost. Her infinite patience and her demanding sternness kept me focused whenever I ran into writer's block, life's distractions, second thoughts, bouts of laziness or just sheer boredom. She must have painstakingly reminded me a myriad times that dreams, talent & passion have to be supported equally by determination and hardwork for any desired outcome. **Papa (Vijay)** was my editor-in-chief. This book would have not seen the light of the day if it had not been for him, for his belief in me, in my story and his tireless efforts in editing, scrutinizing, proofreading, formatting and providing constant critiques to ensure the narrative flowed well. He kept pushing me to think far beyond the story of Serena Williams, to explore its philosophical aspects, to read up on the Civil Rights movement, the issues related to Climate Change, to illustrate the book, to give titles to chapters... His self-discipline and commitment to his own daily writing in spite of long days at work are awe-inspiring.

My younger brother, Siddharth, hasn't actually read my book yet, but, his vast knowledge about animals came in very handy in generating fish puns.

Thank you **Bai** (my paternal grandmother), for always boosting my confidence. You are the most resilient and positive person I know, and I always feel the warmth of your smile even when you're far away in India. **Nani** and **Nanu** (maternal grandparents): you gave me the most memorable and one-of-a-kind launch pad as an author last year amidst a large, elite audience of Rotarians. Your constant banter, advice and caring thoughts always lighten my spirits!

I have a slew of other people to thank: **Ms. Alison Tremblay**, my 5th grade teacher at CIS Singapore, who was the source of the idea for this book! She painstakingly proofread all my writings, whether it be for the Poetry Slam, or entries for other competitions. **Ms. Sarah Song**, from UWCSEA Dover, one of the best English teachers you will find! All through Middle School she has been incredibly understanding, supportive and encouraging. You have made me love English more than I could ever imagine! **Ms. Alice Henry**, UWCSEA Dover, another awesome English teacher who is forever pushing me to expand my breadth of reading. Since I've been in her class, I've learned many skills on how to be a better reader and writer.

I am extremely grateful to **Ms. Shivalik Pathania** (Shivalik Aunty), another fabulous English teacher, for carving out time to proofread and fine-tune my first draft and giving me extremely valuable feedback for both this book and my Queens Commonwealth essay. A sincere thank

you, **Mr. Abhishek Tiwari**, for making my book cover look stunning, and for spending countless hours formatting all the small technical details with my father. **Ms. Sarah Brennan**, for inspiring and motivating me to pursue my passion; **Preeti Masi, Amit Masaji, Poonam Mami & Amol Mama** for being my strongest cheerleaders, and **Sahil, Sameer, Aarush, Samara & Shivaan** for being the most awesome cousins in the universe! My sincere and humble gratitude to all the donors to my initial **Clean Drinking Water Campaign** when I launched my first poetry booklet - you have inspired me to keep working for the things I believe in.

And finally, I want to thank **Serena Williams**. You are a role model for many like me to stand up for what you believe in, to never give up hope and confidence even in the darkest times, to take a stand against discrimination of any sort, to not let society define your beauty and/or your worth and above all to be human, to play hard till you succeed and to learn and rise above mistakes. Your story amazed me since Day 1. You said once in an interview that when you grew up, you wanted to be someone that other little girls would look up to someday. You may have heard this before, but I can tell you that you most definitely have succeeded in that.

All right, let's get on to the story - all hands on deck! The Ship is just about to sail!

Fishious Foreword

Dear Human Reader:

This book has been translated. It was originally water-woven in Searabic, a common form of sonic communication amongst sea creatures. Translating Searabic into a written language of a different species is hazardous business, and if done incorrectly, can be a total shipwreck. We hope that we have avoided this maritime disaster.

We in the Ocean do not speak English, but our sources - *fish which have escaped your cruel nets and harpoons* - tell us that for you, it is a widespread form of dialogue. Having studied many of your plastic labels and cans we have recovered from all the rubble and detritus you dump in the blue ocean, and the books from ships which have sunk over the centuries, our learned linguists have recreated a rudimentary understanding of this earthen language. They have attempted to correct the spelling, grammar and consistency issues which tend to occur in what is surely a bit of a fishy translation. Please excuse any mistake we may

xvii

have overlooked.

All fish ages have been translated into the human equivalent for the readership's ease. Where needed, we have added sidenotes to facilitate further understanding of our terminology, as well as a glossary of some common terms.

Our shoal is confident you will find this rousing tale of a fish swimming up from the deep trenches to great heights both inspiring and uplifting. One can only hope that the lessons on fishism we have learnt will help you address your own issues with racism and social boundaries. It is our fervent wish that your scholars will translate some of your great works in Searabic so that we may partake of your learned waters, too.

This book is waterproof. It has been printed on recycled reeds and seaweed. No human was harmed in the creation of this book.

Declaration
of
Fishium
Rights

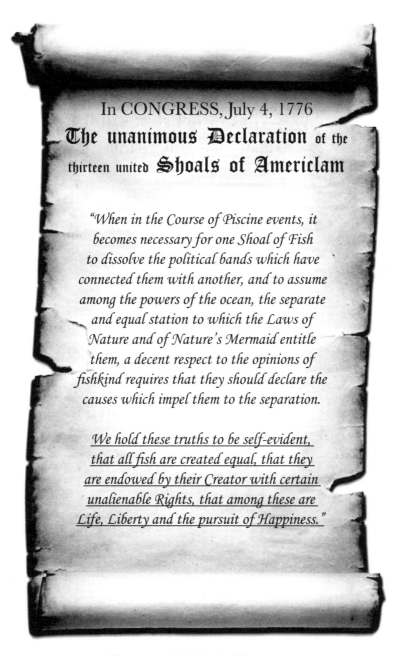

In CONGRESS, July 4, 1776

The unanimous Declaration of the thirteen united Shoals of Americlam

"When in the Course of Piscine events, it becomes necessary for one Shoal of Fish to dissolve the political bands which have connected them with another, and to assume among the powers of the ocean, the separate and equal station to which the Laws of Nature and of Nature's Mermaid entitle them, a decent respect to the opinions of fishkind requires that they should declare the causes which impel them to the separation.

We hold these truths to be self-evident, that all fish are created equal, that they are endowed by their Creator with certain unalienable Rights, that among these are Life, Liberty and the pursuit of Happiness."

(Excerpt; underlining by Narrator.
Source: US Declaration of Independence)

The Constitution of the United Shoals of Americlam

Ratified: June 21, 1788, with subsequent Amendments

We the Fish of the United Shoals, in Order to form a more perfect Union, establish Justice, insure domestic Tranquility, provide for the common defence, promote the general Welfare, and secure the Blessings of Liberty to ourselves and our Posterity, do ordain and establish this Constitution for the United Shoals of Americlam...

Article 1: All fish are born free and equal in dignity and rights. They are endowed with reason and conscience and should act towards one another in a spirit of fish-hood.

Article 2: Every fish is entitled to all the rights and freedoms set forth in this Declaration, without distinction of any kind, such as race, fin colour, gender, language, religion, political or other opinion, national or social origin, property, birth or other status. Furthermore, no distinction shall be made on the basis of the political, jurisdictional or international status of the shoal or school to which a fish belongs, whether it be independent, trust, non-self-governing or under any other limitation of sovereignty.

Article 4: No fish shall be held in slavery or servitude; slavery and the slave trade shall be prohibited in all their forms.

Article 5: No fish shall be subjected to torture or to cruel, unfishy or degrading treatment or punishment.

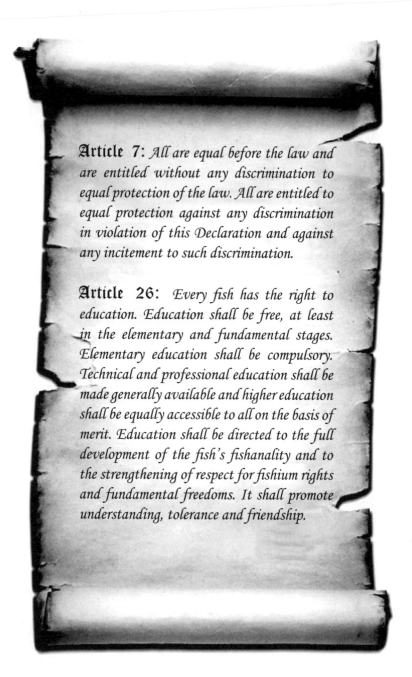

Article 7: *All are equal before the law and are entitled without any discrimination to equal protection of the law. All are entitled to equal protection against any discrimination in violation of this Declaration and against any incitement to such discrimination.*

Article 26: *Every fish has the right to education. Education shall be free, at least in the elementary and fundamental stages. Elementary education shall be compulsory. Technical and professional education shall be made generally available and higher education shall be equally accessible to all on the basis of merit. Education shall be directed to the full development of the fish's fishanality and to the strengthening of respect for fishium rights and fundamental freedoms. It shall promote understanding, tolerance and friendship.*

(Excerpt. Source: US Constitution)

𝔓rologue

"Everybody is a genius. But if you judge a fish by its ability to climb a tree, it will live its whole life believing that it is stupid."

~ *Albert Einstein*

The beach is calm; light waves roll upon the sandy stretch, flowing gently into foamy sweeps. The horizon is blurry and soft, the ocean scattering up into the sky. There's a boat to the far right, looking small, insignificant.

It's much bigger up close, and thick, black poles lean against the inside walls. They're fishing poles, left scattered in heaps for lunch. One man is fishing, though, youngish and slightly new to the art. His pole moves a little, quivering at every shadow in hopes of tempting a swimming creature to

1

the bait. Ripples meander through the breeze and something glitters underneath.

The man jerks his fishing rod up, swaying forwards, backwards, forwards, backwards... and suddenly - he's in the water, splashing and flailing, scrambling to find crevices in the boat's sturdy sides to hold onto.

It is then, through the water's violent heaves, that a stroke of discord is seen, a shard of discontentment. It stays there, poised, as if debating with itself whether to show its true anger or close up on itself again.

It decides.

Ancient curls of watery flaws are not reason enough to spoil a pleasant morning; there would be other days to reveal the monsters lumbering beneath the surface. Swallowing its fury, its pain, the wave in the water carries the man back into the boat, and then flickers on, endless in its wake.

Calm. Serene.

Sometimes, there is far more *sub rosa* than there is visible on the surface.

~*~

Prologue

INIQUITIES ~ VIGNETTE 1

The fish slumped against the blood splattered ropes, on the verge of going unconscious. Three more lashes to go, and then he would be shaken awake, reprimanded, spit on. He would then drone out, head down, tail down: *"I apologize for spilling tea on Missus's dress. Should such a thing occur again, I will be punished with twenty lashes."*

The electric-eel whip stung, burning every cell in his body. If only it could stop.

The group - those waiting in a staggeringly long line - stared at him, as they were forced to do. They were awaiting their own lashes, punishment for being slaves. Punishment for being born as they were.

A lady gasped, mouth contorted in sobs. *Hold on.*

The fish choked and blood fell from his lips.

Hold on. Hold on. They prayed for him, for he just needed to endure one more lash.

Hold on!

He couldn't. His limp blue fins hung shamefacedly as he fell, falling down the furthest he could go.

He didn't get up.

~*~

INIQUITIES ~ VIGNETTE 2

Her new name was Becky. *Becky* was to clean the house and do the cooking and sew the dresses for the daughter. *Becky* was to obey every word the Missus and Master said. She was to speak only when spoken to, and only in the form of a question, apology or clarification. This was very kind of her Missus, to allow her to talk. If for any reason, *Becky* was not able to perform her duties to an acceptable standard, a suitable punishment was to be discussed.

Becky was not the same as her old name. *Becky* was not *Beke*.

Two personalities of the same body; yin and yang; devil and angel. So *Beke*, every so often, took a spool of thread out of the Missus's workshop, and when it was Market Day, she would sell it for a sand-coin. *Beke* was the one who forgot to chop the onions, and it was *Beke* who would land up missing a few stitches on the daughter's dresses, causing the silky fabric to fit too loosely.

Every punishment *Becky* endured, *Beke* grew stronger. So much so that she had started to talk, starting with a few words and ending with a sentence so long it landed with a rolling pin slapping her back.

She snuck out one day.

Swim fast, swim fast! On and on and on...

Prologue

And even while *Becky* was caught, whipped and tortured, *Beke* kept on swimming.

On and on and on.

~*~

INIQUITIES ~ VIGNETTE 3

"Shh." The yellow fish glimmered in the night, cloaked in a woolen brown coat. It blended in with the dark waters.

"Shh, or they'll catch you!" The blue fish opposite him was not wearing a coat. He shivered in the frigid water, clutching his small, blubber bag of belongings.

"If anyone finds you, it wasn't me. I'm only helping you because you helped me. I'm only helping you because… because I think you're a friend." The yellow fish spoke quietly, not wanting to be heard. He turned away, his face hidden in the gloom. It was the best goodbye either of them could hope for, at least under the circumstances in which they found themselves. So the scrawny blue slave, who looked too young to be sixteen, swam off, slinking into the night. Across from him, the yellow fish ducked back through the garden, never glancing back. Looking back would allow compassion to thread his mind, and compassion was dangerous.

In a world that seemed drained of it, empathy for the seemingly unworthy was a clearly labelled death-trap.

One
In the Shadows of Greatness

"If you have to make laws to hurt a group of people just to prove your morals and faith, then you have no true morals or faith to prove."

~ *George Takei*

The fourth window in the Gilliams household was illuminated with light. Shadows sheathed the brick walls, silhouetting three distinct fish. A faint chattering floated out, every so often ascending into clearly formulated words and gestures.

"Daddy, look! Rosa Sharks!"

"And that's Marlin Fisher King, Jr., speaking up for the Blue Fish's rights!"

Once Upon A Fishbowl

It was 10:00 PM; way past the bedtime that Mr. Gilliams had printed on his daughters' timetables. From the depths of the purple-shelled room, Mr. Gilliams yawned, regretting the promise he had made to the girls after they had won a game of friendly Bubble Ball. Two rounds of storytelling, replete with accents and actions, was much more tiresome than he had anticipated.

"Okay, Daddy, read the second book!"

Mr. Gilliams forced his eyes open, flipped open a smaller, slightly worn copy of 'Waves of Blue' and cleared his throat. A cloud of fine sand billowed out into his fins, and a hazy drawing of a blue fish peered back at him.

Having experienced fishism countless times (Sharknaw, Fishigan, had its fair share of scale-color inequity), Mr. and Mrs. Gilliams wanted their children to understand the history of their home, of the suffering past generations had endured, and learn about the impact degrading words and actions had on members of the fish society. For this reason, amongst a few others, the Gilliam's had marked off a square on their glossy calendar to signify a trip to the bookstore, hiked up past *Finny's Fish Foodery* and set a crisp sand-dollar 3.29 on the counter for an old, dusty, turquoise picture book, *'Waves of Blue'*, the stirring story of the Blue Fish community's long march toward social acceptance and equal civil rights.

The girls curled their fins under the covers, squirming in anticipation. Mr. Gilliams started to read:

I believe that you refer to 'fine sand' as "dust" up on earth (Yes, there is an "I". "I" am simply called "Narrator". You'll see me quite often.)

"Once upon a time, there was a fish named Rosa. She wasn't a princess. She didn't have a castle, or servants, or fancy ball gowns. On the contrary, she lived in a mediocre home, had a mediocre amount of money and lived a very mediocre life. In comparison with her yellow neighbors, she was poor; not just in money, but also in class, status and career opportunities.

Rosa was an ordinary, normal fish. She had two fins, a curly tail, two eyes, a pair of gills and all the other things that a fish tends to have. As a child, she went to the 'Evergreen Public School for Blue Females' every day of the week, did the chores in the house, played in the back garden only after 4:00 in the evening, and had dinner at 6:45 pm. As she grew older, her jobs changed, but her tasks retained the same monotony; cooking, clearing up living room

9

clutter, watching the telefishion (when it worked), shopping. And yet, she was treated differently. As a lesser fish, as a lower breed. She was, after all, blue...

Rosa was banned from certain stores and buildings, as were the other blue fish, and she could only swim on the dirtier side of the current, where octopus oil from the aquacars tended to accumulate. Wads of muddy plastic and soggy sediment skittered by her, 'accidently' flung from the yellow fish's fins. Slurs were tossed at her carelessly, digging into her fins long after the yellows had spewed their casual venom. She was regarded as a second-class citizen, worthy of only disdain and ill-treatment at the fins of the "fairer" fish.

She was still better off than most of the blue fish. Everyday brought reports of the killings and indiscriminate jailing of blue fish. For the slightest of things - conversing with a yellow about political matters, drinking from the "wrong", non-designated fountains, sitting on a nice Stingray - blue fish would be imprisoned. It was not unusual to see a blue fish being lynched or seeing the burning down of their kelp sanctuaries. Threats, harassment and verbal abuse were common currency used against the blue fish. Complaints of a yellow fish harassing or harming blues were filed into the "Pending" box in the police station. The "Pending" box was a mere joke to the officers and citizens alike; a file lodged

In the Shadows of Greatness

in that particular peach compartment meant that it would only be looked at once the box had to be cleared in the recycling bin down the hall.

Inequality was rampant. It was a shared thought - only blue fish could be bad.

How grim was the situation, you ask? Well, let's take you on a tour to the past... You, a traveller, have just arrived into the Great Reef Whaleport. Your luggage is holding you back so you drop it off at the infamous Grand Hotel and then decide to explore. You are immediately struck in the gills by one thought: This fishdom flaunts fishism... *Writings dribbling with bigotry are waving in the water everywhere. Signs like,*

' No Sea-Dogs, Blue Fish or Mexican Bonitos! '

' Yellows ONLY! '

' Yellows Waiting Room, This Way '

adorn the elegant, pearl-studded buildings which encase the yellow fish. Yellow fins file through stone archways, fresh, lipstick-stained mouths laughing and chatting loudly about tail extensions and finings that they had bought from the Yellow Corner Store. A few children play hide-and-seek on a pitch and you stop for a while to appreciate their grins as they are rewarded with lavish ice cream cones. You continue,

11

not wanting to miss out. Behind the labyrinth of malls, arcades and spas is a dark fence, laced with jellyfish tentacles. Sharp spokes rise out through the spires, girded with electric eel tails and sperm whale teeth. There are passageways dug out through the structure, crawling with graffitied slurs, and you cautiously swim underneath. Blues can only live on this other, smaller side. Caked in algae and moss, the barricade is left to rot on the side of the blues.

On this side, your eyes meet only rickety structures draped with browning seaweed. There isn't enough space for the population, so homelessness is common, and you have to carefully avoid the splayed out cloths and buckets that make up 'homes'. There is no Corner Store, and your stomach grumbles, expectantly. Your rich lifestyle hasn't equipped you with resilience - none of the restaurants serves the food you want. All the archways are crumbling, and the ones that remain intact are rarely used. You soon learn that that the dilapidated blue fish buildings can collapse and crush you at any moment. Octopus oil clouds over the Blue side, tying a permanent blindfold of sickness and confusion around the dark-finned fish, and yet aid is never fully supplied; the only hospital in the area was ransacked over three years ago, and no one had any money, time or will to fix it.

Gang fights are normal. Fishes swim around, dodging darts and shark-tooth daggers without

noticing the omnipresent violence. The disturbing chaos, turmoil and the low regard for fish life are typical happenings for them, as normal as reading a newspaper or commenting on the weather. You clamp your fin over your nose, trying to block out the stench. Amidst all this squalor, surges of fish float about, smoking seaweed and drinking aquahol. Ruffian fishes attempt robbing other fishes' sand-dollars (you quickly hide your wallet) so that they can pay for daily necessities - basic food, seagrass clothing, children's education.

Education... Sixty fish crammed on some wooden benches in front of a cracked blackboard and one tired teacher threatening to hit anyone who disobeys with her scaly cane. They learn about slavery, about Crab Lincoln, the fish who fought for slave rights. They learn about famous Yellow fish, great inventors and scientists and mathematicians. They learn about their fishdom, the Jim Kelp laws and the manners they must maintain when in the presence of a yellow.

They never learn to appreciate the Blues, or the pride of being one.

A few weary ladies drink from the old white-shell water fountains which have been handed down after the Yellows got nicer, aquamarine ones. Every fish knows that drinking normal water is poisonous; it has to be filtered out to take out any debris, chemicals

and harmful particles. But sometimes, the yellows "forget" to filter out the water on the blue side, and then even more sickness threads around. So the fish have to live with the pain and the fear, working tirelessly around the roadblocks that are continuously being constructed. The only thing, really, that the Blues and Yellows share is the Stingray Express and the Pilotfish Flights for travelling overseas. In both cases, the Blues sit at the back, and the Yellows in the front.

You try to forget the things you saw. It's easier that way. Besides, you have a movie to catch, and a bucket of popcorn to attend to, along with the group of friends you've invited. You make your way back to the hotel, forgetting things the further you get away. You forget the sickness, the begging. The children playing in old boat wreckage. The dividers between color. It's meant to be equal.

Separate, yes, but equal."

Mr. Gilliams paused and looked up at his daughters. They were aghast, the frozen look of horror drawn large on their young faces. Was the seaworld really so hateful, so cruel? Where had the fish lost all their tenderness?

"Read", Selena urged her father soberly. With a caring glance at them, Fishard resumed his reading:

In the Shadows of Greatness

"Rosa had a nicer home than most; she had a job, and sufficient money while growing up to afford an education. She was smart, quiet and friendly, and normally followed the segregation rules without any sign of complaint. Fishism hadn't grasped her at the depth to which it had reached other, more targeted fish, especially teenage boys and burly males (at the time, female fish weren't really considered as equals, much less a threat). But deep inside, she knew how unfair things were. Speaking out could cost her many of the things she was lucky enough to own, but lately, it was proving to be harder and harder to keep her mouth shut.

Social discrimination came in other forms, too, for fish are a very creative species. They discriminated not just based on fin-color, but also against many other categories based on specific characteristics of marine life. Fish of different oceanities were called derogatory slang names, were shunned, were hurt simply for being of a different geography. Those with different "Mermaid Beliefs" were harassed over differing religious faiths. Genders were stereotyped. Able-bodied male fish were typically the only ones considered suitable for out-of-home jobs, while females were considered better tailored for the kitchen chores, raising frys and cleaning. It was also understood by extension that female fish were not as smart as males, and were not geared toward the hard-sciences. Of course, that did not mean that blue male

fish were smart. That's another hierarchy altogether. Blue *males could get labor-intensive jobs, but weren't accepted in the fields of Physics, Mathematics and the like.*

Being a blue fish, and a girl fish at that, was not easy. Rosa had resigned herself to that conclusion and resorted to quiet contemplation, mouth pursed and set in a perpetual stoic pose.

One day, when Rosa was going over to her friend's house, she decided to use the Stingray Express. Normally, she swam, but she was extremely tired and her friend was a fair distance away. So she packed her bag with a sewing kit, a small carton of salmon crackers and a jug of filtered water, filled her pouch with seven sand-dollars, and made her way to the Stingray Stop. It was crowded, as usual, and she was jostled around roughly.

"Move it, blue fins!"

"Hey! Blue fish! Get out of my way, I'm late."

Rosa, being a petite fish with small glasses and a timid frame, shrunk slowly, inching forward only when no one was looking. If anyone saw her, he might accuse her of trying to cut the line. The cracked timetable nailed to the wall was curling at the corners, but she could see the faint green line signifying her journey. It was due to arrive in a few

seconds, and she had made it just in time. The next Stingray was turning the corner, and Rosa looked at her watch. She was very nearly late herself. Stingrays arrived at five-minute intervals, but before she could get on, a snake of yellows cut past her. One of the ladies frowned at her, shielding her child and bustling forward. The Stingray sped off, with Rosa left behind, gaping, but not surprised. It wasn't the first time it had happened. Still, she couldn't help but recall that when a blue fish had accidentally done the same thing two weeks ago to a yellow fish, he was sentenced to three months of imprisonment and hefty fine for 'endangerment of lives.'

Another interval passed, and Rosa pushed her way forward, this time strong and noticeable; she wasn't going to miss yet another Stingray to the Yellow crowd behind her. As she boarded, she took out her purse. It was a sand-dollar extra for the Blue Fish, and Rosa paid her fare of three sand-dollars. Apparently, it was not enough. The plump, greasy driver glowered at her and told her to get off the Stingray and enter from the back, where the swishing tail of the Stingray droned with electricity. Most of the seats in the Blue section were occupied, and the ones that remained at the very back were the only ones Rosa could sit on, despite the fact that there were a handful of seats reserved for yellows still available.

The driver sneered.

Once Upon A Fishbowl

"Now, we don't want any of these fine ladies and gentlefish to get bothered by you, do we? Your big, fat fins brushing against them to get to where you belong? So enter by the back, like a good law-abiding citizen."

"But, sir, surely you understand, the tail... it'll sting me!"

The driver frowned again and gave her a small push.

"Enter from the back before I call the police, you filthy blue fish!"

Rosa sighed. There really was nothing she could do without getting into trouble. Arguing would get her kicked off, moving forward by force could get her jailed, and complaining could result in either or both of the those. In the current society, sometimes it was best to remain in the shadows, unnoticed and unproblematic. Dazed and hurt, Rosa gathered her things and made her way off the heaving, tired bus. However, before she could swim back on, the Stingray sped off, leaving a trail of white, simmering bubbles and the sound of the driver's cackling laughter. Enraged, Rosa flicked the sand with her tail, but all it resulted in was a sore spot, blooming on her fins like a sin. She hadn't expected this. Tossed next to her was her stitching bag that she had used to create a beige hat for her friend, Shelly Turtley. A

ball of plankton string rolled from underneath the bag and glimmered a pale blue. The bag now had a hole, easily sewable but time-consuming. Her needles were sticking out, a piece chipped off from the left one and Rosa's little purse of sand-dollars jangled as she went to retrieve the stray ball of string. It struck her that her fare of three sand-dollars was still with the driver, and she felt her anger rising.

She couldn't do anything, no matter how upset she felt, or how unfair it all was. The Stingray was long gone, and it wasn't actually against the law to tell someone to get off a Stingray if one was accused of 'disrupting the peace'. And knowing the bus driver's demeanor all too well, she knew he would probably have concocted a story and she would have been thrown in Jellyfish Jail. It wasn't as if any of the other blue fish would have stuck up for her. They were all too scared of being arrested and punished themselves. It was then that she realized: no one else was going to support and stand up for her or for all the schools of fish with dark fins. Nobody was brave enough, nobody courageous enough, nobody... except...her. An exhortation welled up inside her:

"If not YOU, WHO?"

Two months later, Rosa was on a Stingray Express, staring out at the speeding houses. She was on a nice, flat piece of skin, farthest away from the swishing,

electric tail of the Stingray, situated right behind the yellow section, which was currently almost full.

The Stingray groaned to a stop in front of a pale green Stingray Stop. Two fishes got on, the first one a middle-aged yellow male and the second one a young lady with a giant gill-ring. There was only one Yellow seat available, and the male fish graciously gave way for the yellow lady. Rosa continued to gaze at the surrounding neighborhood. The yellow fish turned his eyes toward Rosa, scrunching them with disgust. The driver came up behind him, first scanning the yellow section, and then finally resting on Rosa, mirroring the first fish's expression; repulsed at her face, her fins, her tail.

"Hey! Blue fish! Are you going to get up for this gentlefish over here?"

Rosa pretended not to hear and only turned slightly when she was violently prodded by the drivers thick fin. She glanced at the rest of the Stingray's occupants, eyes glazed over in quiet fury. She looked at the driver, seething, and straightened up with a firm voice.

"No".

Years later, in more egalitarian times, she spoke of this defiance in an interview, "I did not feel any fear sitting there. I felt the Mermaid would give me

the strength to endure whatever I had to face."

Throughout history, one can see numerous examples of fish treating fish unfairly. What drives us to that insecure, power-wielding moment? What allows us to ignore, no, accept this type of injustice? Is it a mere dent in our behaviour? Does something or someone push us towards these barricading feelings, or are we alone with our faults and failed attempts?

Is our sum lesser than our parts?"

~*~

Mr. Gilliams looked at the girls, gauging their wide-eyed, scared expressions. Their mouths were slightly open, blankets clutched to their tiny chests. The current generation could not fully fathom the crushing oppression the blue community had endured for centuries, but they knew a wrong from a right when they read about one, and it showed on their innocent faces. Mr. Gilliams continued reading:

"Jellyfish Jail was dirty. It had smudged stains of red and brown on the walls, and the ground was littered with filth. Left in the corner was a yellow plastic bucket of dead, rotting kelp that Rosa refused to eat, knowing fully well that it hadn't been replenished for weeks. Alone and slightly afraid, Rosa sat with a straight back, eyes assertive. Her peace and confidence in her own righteousness flowed from the philosophy of the great visionary, Mahafish Gandhi,

whose stubborn principle of "Insistence on Truth" - 'Satyagraha' - had fueled the confident defiance against the prevailing tyranny of an entire nation of purple fish in the Indian Ocean.

Gandhi had been an unlikely figure to become a rallying icon for any school of fish, let alone a nation suppressed by a foreign imperial rule for hundreds of years. Frail and soft-spoken, he could have been swatted down by the slightest flick of an urchin-whip. Instead, with an unshakeable belief in his path of Non-violence and Truth, he had organized unstoppable campaigns of large-scale protests, strikes, non-cooperation, and outright non-compliance with tyrannical laws and statutes, which raised the national fervor of all the purple fish to a crescendo which could not be ignored, till the oppressing empire had to retreat and grant Indian Ocean its freedom and sovereignty.

Gandhi's thoughts had become Rosa's.

"In a gentle way, you can shake the sea.";

"Strength does not come from a fish's physical capacity. It comes from an indomitable will.";

"A fish is but the product of its thoughts; what it thinks, it becomes."

In the Shadows of Greatness

Gandhi's thoughts were as relevant in the United Shoals as they were in a captive Indian Ocean under duress.

Just a few miles away, whispers and gossip about Rosa's heroism danced around the blue fish community. News of her arrest had spread far in rapid underwater eddies. The match she lit with her confidence flared up, searing the haystacks around her, and rampaged through the timid hearts of her neighbors and friends.

Following up on her boldness, small acts of courage unfurled, unnoticed by the yellows but rousing up the blues. When no one was looking, blue fish started drinking water from the "wrong" water fountains and using the Yellow toilets. Most of the admonishments in racially charged boards started getting ignored. Some graffitied the Yellow walls, splattering accusations and defiance against the treatment of the blues. Civil disobedience took root. Noise against racial segregation started to gather up in sympathy. Four days after Rosa's imprisonment, blue fish in the entire shoal-city of Montgomery started boycotting Stingray rides to protest the inequality. It was a movement which triggered the nation's "shoal-searching", so to speak. Within a year, the Supreme Fish Council of the United Shoals of Americlam had ordered desegregation of the bus system in Montgomery, bringing it a step closer to

the norms of a civilized society.

Finally, the wheels of revolution had been set into motion ..."

Mr. Gilliams stopped, yawning once more. Immediately, the two smaller voices chorused out, "Keep reading! Keep reading!" The room relapsed into silence for a moment, before Mr. Gilliams relented, quickly glancing at his watch, "Fine. But I'm only going to read the ending bit. It's too late for me to finish this book, but I'll read it to you some other day."

"That's okay. Can we read the speech part?"

"Start at Marlin Fisher King, Daddy!"

A few page flips, some excited giggles and a sigh later:

"Marlin Fisher King Jr. looked out at the blue crowd, spotting a few flecks of yellow in between. He had joined the fight for freedom ages ago, and yet there was so much more to be done. A deep breath.

"I have a dream," he spoke into the megalophone.

"I have a dream that one day, my four little fishes will not be judged by the color of their fins. They will be judged by the content of their character."

Applause filled the waves, and Marlin was encased in a whirling mass of bubbles. The propped

up campfire of freedom, so carefully erected, had finally blazed into a forest-fire, propelling millions of blue fish into a new world, in which they could choose their future. In which they were leaders, models and teachers. Where they could speak and laugh alongside the yellows, and where every fish was judged...

... not by the color of its fins...

... but by the content of its character."

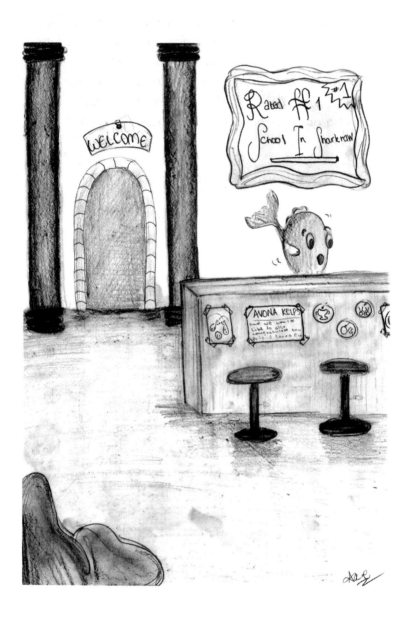

𝕿𝖜𝖔
Floating Dreams

"Things are not always as they seem. The first appearance deceives many."

~ Phaedrus

𝕱ishard Gilliams finished reading aloud and glanced down at his daughters. After an hour of reading, the two toddlers had finally dozed off, slipping away into slumber as their father reached the last few sentences. The late night glimmered with enveloping darkness, and Fishard yawned drowsily.

Selena tossed a little in bed, and Mr. Gilliams swam out of the room, switching off the anglerfish-light and slowly closing the hatch of golden clamshells. On this was a picture of Selena, Neptuna and their father, a bubble bursting on

Once Upon A Fishbowl

Mr. Gilliams' tail. Underneath was a tiny wooden sign, with the words:

'Neptuna and Selena, Bubble Ball WINNERS!'

scrawled in red crayon. The fish had taken the picture a few months ago, and Neptuna had taken great pride in writing the sign with her wobbling, four-year old finwriting. Smiling, Fishard checked on Yetunde, Lyndrea and Isha's respective rooms, which were just across the hall. Unlike their younger sisters, these girls had fallen asleep on time. Their mother was always better at tucking the frylings in.

Fishard went to his room, carefully closing the door so as not to wake up his wife, and flipped through the small paperback book on his bedside table. It was a short collection of Bubble Ball biographies, including elites such as Althea Gillson and Steffi Grayfin, two of the most renowned and distinguished female Bubble Ball players of all time. However, even that was not enough to keep him awake, and within moments, the entire Gilliams family was sound asleep (with eyes open, in the way that biology demands), dreaming through the Saturday night.

~*~

In his dream Mr. Gilliams smiled contentedly. It was a vivid realization of his aspirations, a reach into the future which he wished sculpted.

"The filtering rays of the watery sun were brighter

28

Floating Dreams

than usual, and Mrs. Gilliams applied thick smears of brine-block on little Selena and Neptuna. Their braided hair whipped the humid, balmy water as Mr. Gilliams tried to fit the hats on their heads, and finally, they swam up onto the court. Their mother, who had just retired from a game of Bubble Ball, sat back in the shade, sipping a small glass of red algae. The tiled octopus table was decorated with plates of crisp water-lemon, salted crab-apples, blue seaberries, wrapped stacks of sandwiches (tuna, algae and sea cucumber) and a collection of crackers and drinks. The pitcher of pure, homemade Agarade sparkled in the sun and little cups with folded umbrellas were set out on the table. Yetunde and Lyndrea were playing in the nearby park, but Isha sat to watch them. Unlike her sisters, Isha enjoyed hitting a few bubbles from time to time and watching her stumbling siblings on court.

"Okay girls, I'm going to feed the ball and you need to hit it back to me."

Mr. Gilliams crouched low so he was at the same level as the girls, and started to feed some bubbles. Immediately, a chorus of pops, squeals, giggles and hits commenced, resulting in two very tired and Bubble-drenched little fish and one amused father. Every bubble hit had either popped, been netted, or called out by Mr. Gilliams.

Once Upon A Fishbowl

Selena rushed to the checkered table and gulped some water from her pink, small bottle and Neptuna followed after picking up her discarded hat which had fallen off during the chaos of the game. Some crab-apple slices and krill crackers later, the girls resumed their position, finally 'ready' to start their traditional Bubble Ball game."

For Mr. Gilliams, the dream-snippet was page 3 of his 78-page master plan of shaping his daughters into world-class players. By the final page - which he always saw in his dream - the sisters were undisputed, unbeaten Bubble Ball champions in all of the world's oceans.

Through the hazy half-consciousness in which Fishard slumbered, he could appreciate the true beauty of his home. The sodium light filtering down into Lake Fishigan from the Overland gave the waters a mystical orange hue. Soundless serenity pervaded within, as the world below pulled the comfortable shawl of silence over itself.

~*~

The next day, as the water trembled with scintillations in the morning light and the gossip of neighboring fish surfed the waves, the mailfish delivered a small, glossy fishizine to each house. It was a squarish shape, with a rounded edge for the fish's to flip the page (sharp edges are dangerous to fragile fins and are banned in all artificial processes in the marine world). The surf-glass chimes that hung from the Gilliams' front door rang out and Mr. Gilliams, looking

slightly disheveled, swam out of the coral door. Mail usually only consisted of electric-eel-power bills and the always-negative daily news, so he skimmed through the new arrival eagerly.

"Can we go and play with the other fishes out in the park? They're playing Sharks and Minnows, and Whaleena Dean says if we're there in five minutes we can be FISH. Please?"

Startled by the sudden, clear voices, Mr. Gilliams turned around to see two, pajama-clad fish, one with a stuffed turtle held in her fins. There floated Selena and Neptuna, normally the latest risers in the family.

"Up so early, girls?"

The two fish glanced expectantly at each other, hoping that they had succeeded in convincing their father. Doing something on time carried its reward, didn't it?

"Maybe you can play with them tomorrow. Today we're going to "Bubble Ball Coaching" to sign you up for training!"

He waved the fishizine, which stated in bold letters

'Bubble Ball Coaching, Opening Doors for Younger Fish!',

in front of their faces. Their eyes, which started narrowing in disappointment, suddenly flew open. They

were still learning how to read, but once they had deciphered the bubbly letters, they opened their eyes even wider. Bubble Ball Coaching was much better than an insignificant game of Sharks and Minnows.

"Do… do you mean that we'll be able to learn Bubble Ball? In an *actual* school?" They asked, Whaleena Dean all but forgotten.

Mr. Gilliams beamed at the fishizine, flipping some pages to show them more pictures. There was a picture of a coach and five smiling fish, each holding a bubble. Behind them and in the remaining pictures were chrome snapshots of tournaments, trophies and a few of the coaches. The facilities displayed were shiny, new and incredibly appealing; metallic Bubble Shooters, colorful plastic Bubble Aiming Targets, real side spikes from the depths of the ocean. Selena and Neptuna grabbed the booklet, squabbling over who could see it first. Neptuna won, so Selena dashed inside to get something for breakfast. Selena was always hungry, so she brought some extra snacks. Three Shrimp Bagels, a bottle of 'Blueseaberry Juice' (their favorite brand) and a tin of 'Salt of Sea' chips seemed enough, so she hurried back outside, not wanting to miss a chance at pouring over the pages. Finally happy with their fishizine inspections, the two girls waded to the stables to get their seahorses, their dad locking the front door. He had left a note for the three sisters and mother on the fridge.

Neptuna and Selena loved riding seahorses. Neptuna's,

Floating Dreams

which was ebony black with highlights of silver, white and blue, was named *'Starr'* and Selena's was a light golden, shimmery with light pools of pink. She named the seahorse *'Jameka'*, since it had originally come from the waters around the Human Habitat called Jamaica. As a child, she would always say 'Jameka' whilst remembering her seahorse, and it soon became it's real name, despite the countless Human Geography classes in school.

Selena had first learned about Jamaica when they were travelling overseas. They were seated in Porpoise-Class, the one that afforded the best view of the Sky above the waterline, but the smallest tail space. The pilotfish had announced that they were diving near Human Habitat, and that the fishes should fasten their seatbelts and refrain from using the lavatory; flying near Human Habitat caused a lot of turbunets, because of all the fishing nets swaying around. The seat belts were constructed of the soft but sturdy metal, which the sawfish had dug out from under the sea bed. The sawfish were accomplished builders and swimmers, and the United Shoals owed much to their industrious wizardry.

"How can the Hoo-mans swim through that hard ground? I bump my head every time *I* swim into it." She had asked her father. Mr. Gilliams laughed and said,

"*Humans* don't swim! They *walk* on top of the ground, my little one! With their tails they call 'legs' "

Selena still looked doubtful.

Once Upon A Fishbowl

"But how do they breathe? You said we die if we ever go above water for a long time."

"*We* die. Humans don't. They have organs called 'lungs' with which they breathe air straight from the air above."

Neptuna and Selena still didn't believe their father. Another world above the water seemed absurd to their 2-year old minds, and beings that walked on two legs and breathed above water seemed like mythical creatures, stirred up by their father's fertile imagination. Surely anything that lived so near to the Sky was imaginary!

That is, until the fishing started.

Every week, the telefishion would flash new stories about fish being captured and taken away by the "Hoo-mans". They used a terrifying contraption which was long and pointed, and dipped under the water. It normally had food at the end, presumably to lure the fish into thinking it was friendly. And maybe it was! Nobody knew where the fishes went after they were caught, so some adventurous fishes decided to investigate by taking the bait on purpose. They were never heard from or seen again. While everyone was confused and scared, Selena appreciated that the Humans didn't want you to starve. At least you wouldn't go to wherever they took you on a hungry stomach! However, when she voiced out *that* opinion, she was met by worried eyes and small, nervous laughs. Apparently, that one meal was the least of the fish's problems.

Floating Dreams

"I'm coming! Hold your seahorses!!" Mr. Gilliams called out to Selena and Neptuna, who were jumping up and down and feeding the seahorses some Shrimp Cubes. He also had a seahorse, which was light brown in color, with a creamy white tail. He had named it *"Old Whistler"*. As they rode through the waters, Selena and Neptuna chatted excitedly about the Bubble Ball School. Bubble Ball Coaching previously only taught fishes ten years and above, and only on *"a professional scale"*, but was now able to accommodate younger fish.

When they finally reached the neighborhood, they stared in awe at the limestone buildings in front of them. The Coaching facility comprised three towers in total, each four storeys high. The buildings enclosed rows upon rows of Bubble Ball Courts. Glass and metal bridges (which were water-conditioned, express conduits) connected the towers, weaving in between and amongst the floors, decorated with rose gold balconies. Shingled rooftops shaded the lofty structures and arched windows peeked out of the cobbled walls, mirroring sunny water-surface, mossy greenery and grassy seabed meadows. It had colorful coral gardens with bushes of flowers and vibrant anemone, interlaced with bright silver and pink pearl pathways. Clamshell benches and chairs were occupied by waiting parents and their children, and some waved to the family. A few fish were strolling around, smiling at the Naiad sculptures and engravings - pieces of art imported from the Grecian waters of the Mediterranean Sea. To the side, there was a slightly bigger Naiad statue and Naiad-based playground. These Greek

beauties were as rare to the fish as the fairies up above were to the humans; they would only come around if absolutely necessary, and because of their mysterious disposition, fishes had imagined naiads as magical, mythical creatures. An entire mythology had been built around these creatures and their powers in epic works such as *"OddaSea"*, *"Welliad"* and *"Anemoneid"*.

The girls could hear laughter and talking echoing from within the perimeter, and they shifted closer to their father, towards a small hole in the mesh netting that peeped through the second and third buildings. They were so close that they could hear the *thwacks* and *bloops* of the bubble as it crossed the net. The bubble was calling out to them, a siren song beckoning their fins to start playing...

"Girls, we'll come back here, but we need to see the place first! Maybe we could ask for a tour. Come on, it looks like the reception is right over there." Their father, also slightly excited, pulled them towards the first building, a few wades away.

Inside the reception room, they swam around, gazing at all of the posters, plaques and statues. They all screamed out appealingly:

"Sign up for our Bubble-Ball Fall tournament and win your way to the top: More info at the counter!"

"Rated # 1 school in YOUR OWN HOME, Sharknaw, Fishigan!!"

Floating Dreams

"Congratulations to our Bubble Ball Starfish of the Week: Avona Kelps!"

"YOUR next coach might be the one who taught ocean-famous RICKY CORALSON! Sign up today!"

When they finally tore their eyes away from the posters and fishizines, they turned towards the receptionist. She was leaning over the aragonite counter to file some papers, but smiled warmly at them when they approached her.

"Hi! I'm Debrah Carpson, but you can just call me Debbie! How may I help you today?"

Her chirpy voice startled the girls, as it cut into the hazy silence of the room. Mr. Gilliams swam forward and studied the brochure, conveniently placed on the countertop.

"We've just come to register for a class. Could you give us a tour?" He inquired. The lady beamed and nodded, which made her bright purple finings swing around. Her scale polish was a Royal Purple shade, and it contrasted very nicely with her pale, cream colored fins.

"Do you like the colour purple?" Neptuna asked, curiously looking behind the desk, where most of the supplies lay neatly arranged. A lilac stapler, lined aubergine paper, mauve pencils and pens, violet shark-tooth scissors, a palatinate purple eraser, and even lavender white out! Debby laughed, glancing down at her desk. She handed Mr.

Once Upon A Fishbowl

Gilliams a fresh brochure to study during the tour, and then swam through a small hallway, motioning for them to follow. As she swam out, the girls secretly smiled at her sparkly fur coat. It glistened a dark magenta.

Fishes do not need stairs as humans do; they just swim up what's called a Tube, which sucks them up into the next level. It's a bit like an elevator, except shaped as a slide. Another misconception is that fish can fly. We most certainly cannot, though we pride ourselves in our ability to breach the water surface (we have learned from the whales and dolphins).

Floating Dreams

She led them up a Tube and into the doorway of another room, where a few telefishion sets were set up.

There was a little refisherator and a few fishizines spread out on a bubble shaped coffee table. A whirring vending machine stood on the side, and slightly tinted windows looked down on the Bubble Ball courts. One of the telefishion sets was displaying a bright advertisement for Bubble Ball Coaching, and a plate of frosted fish shaped cookies lay on a tray. Neptuna and Selena secretly ate a few when their father wasn't looking. The breakfast had been demolished before they had even reached the building, mostly thanks to a very hungry Selena.

"This is the lounge. Our coaches sometimes come here, and we allow students to enter when they need a break. This is also sometimes used as a pickup point for parents when they're running late or have met a delay. Oh, and when we have at-home-tournaments, the visiting team can come here to get settled before the matches."

They continued down a small hallway, turning right at the last door. This room had a small bed and many metal instruments. A slightly ajar cabinet revealed a box of fin-aids, some Q-tips and cotton swabs. There was even some disfinfectant.

"This is the nurse's office. If a fish gets hurt, which is very rare, he or she is brought here. Our nurse, Tailor Reefmond, is very friendly. Unfortunately, she is attending to another fish right now, so you won't be able to see her. However,

when you start coaching, you'll get to see all the coaches to help familiarize yourself. You may have also noticed that I didn't show you the previous rooms. Some of these are storage rooms, for equipment such as Bubble Machines and nets, and some of them are also rooms for the coaches to keep their stuff, or maybe even stay for the night. We are a complete school, with classrooms and restrooms and even shower areas and a kitchen, which makes us ideal for overseas tournaments and training!"

Selena took a peek inside the clinic, and then swam to catch up with Neptuna and Mr. Gilliams, who were following Debbie atop the glass bridge that led to the second building.

In the next building, Debbie led them through the second office which was for tournament sign-ups (meeting a few more coaches and receptionists on the way), the tournament preparation center, the practice wall rooms and yet another doctor's office, this one for more serious injuries. In this office, they got to meet Doctor Shrimp, a small fish with twitching hands and small round glasses. He seemed nervous at first, but once Neptuna complimented his knowledge of the fish's skeleton, he loosened up and chatted contentedly with Neptuna about bones in the neural spine.

Debbie ushered them out and into the third building, which was the smallest of the three. The hallways here were carpeted and lit with warm light, unlike the pearl and marble floors in the other two. A few fish milled around, swimming in and out of doors.

Floating Dreams

"Here's the learning center. This is where fish learn about rules, manners, tactics, strategies and technical terms on court. Of course, most of the little fish will be starting next season, so the teachers are all outside helping the big kids. In the learning center, there are also separate pods for private classes if you'd like that instead of a group lesson. That door over there leads to a small gillnasium and a few indoor courts. Throughout this building, we have rooms focused on training and extra practice, so you'll see many fish using our facilities without supervision, though there are assistants always at hand. And finally…"

Debby pushed open a bright blue door marked 'BB Courts' and reflected light filtered into the building.

"The courts! There are ten normal sized Bubble Ball Courts on campus, and five mini ones, for fishes younger than age six. That means you guys! Every court is equipped with a bubble machine and has side spikes, to create a realistic match-play simulation. The small courts don't practice with real bubbles yet, but rather light and soft water balls. This means no rallying; we don't want kids to get distracted trying to hit the Bubble. The coach will feed you the bubble, you hit it and it floats over the net before popping. The water bubbles can only stay in its shape for a certain amount of time. And don't worry; you don't have the side spikes either, just in case you trip and get hurt. We have markings for that. You'll have theory lessons most of the times; we like to ease our players into the game. You'll likely get one or two lessons on court per month. Oh, and tournaments will start when

you're eleven years old."

Selena and Neptuna, had thought that Bubble Ball Coaching was the best school ever. Now, they frowned.

"You mean we don't get to use the big courts? We won't get the side spikes? *Or* the bubbles?" they asked. Even Mr. Gilliams looked a bit disappointed, slowly gazing around at the happy fish. The lady's grin faltered after seeing the fishes faces.

"Well I'm sure after Coach Bayswim sees you, he'll be able to judge whether you're ready for the big courts. It's part of our *spectacular* curriculum, you see? You asked about pricing earlier - a group lesson costs fifty sand-dollars per class, it's a one and a half hour class, and you must pay in advance for a season, which is seven classes. Private classes, or duo classes costs forty-five sand-dollars per fish. Like the other classes, you must pay in advance. It's worth it!"

The Gilliams' nodded doubtfully.

"We'll think about it. Maybe call and let you know tomorrow." Selena's father said slowly. Reluctantly, they crossed the courts to the back exit.

A flustered Debbie tried to swim after them, running through things to say to help get them back. But they had already left. Seeing that she had new guests, she straightened her purple coat and swam back for another tour.

~*~

Floating Dreams

"They'll be too soft on you. And besides, what kind of Bubble Ball Academy doesn't practice with bubbles? You guys won't get any rallies, no training, you'll be cooped up in a classroom and playing with markings... *Markings!* For *fifty* sand-dollars!"

Mr. Gilliams explained to his daughters as they glumly stared at the telefishion set. Selena sighed, switched it off, and swam quietly to her room, followed by Neptuna. Mr. Gilliams, also anxious, went to put them to bed. It was there that he saw the picture of the family playing Bubble Ball. Smiling, he quickly swam into the room.

"Girls. You didn't let me finish. I've decided that *I'm* going to teach you Bubble Ball!"

Yes, it's me again. I told you to get used to me.

Well, so about these sand-dollars. Let me shed some angler-light on these. Sand-dollars were invented in the murky depths of time a few thousand years ago as a kind of a go-between in marine transactions. Instead of having fish haul some anemones to exchange for plankton, or heft around bundles of kelp for shredded mussel, some wise king-fish long ago devised the concept of "mammon" - what humans call "money". Mammon was a commonly agreed medium which fish accepted as temporary store of "credit" or "value". If you had mammon, it meant you could go obtain things from other sea creatures by

giving them an appropriate amount. For example, a fish gave her kelp to another fish in exchange for some agreed amount of mammon, and some time later, she gave part of that to yet another fish in exchange for some hardened coral for house-building. Or fish worked in the caves or provided services to others, and got paid mammon for their efforts instead of being given sea-whip corals. This way, mammon enabled people to trade at times of their convenience and not when some uncouth wormfish came barging on the door to exchange "stuff". Of course, the only reason people trusted that mammon had any value at all was that the Kingfish told all of them that it had value and they all believed in it. So it was all this trusty-fealty kind of thingy.

The first forms of mammon were simply irregular seabed-stones bearing the kingfisher seal. This later evolved and the fish community accepted many types of mammon - from variegated pearls to broken fishtails and even petrified fish-eyes (!). For the past few decades, though, the fishdom

has switched to using hardened sand carrying the imprints of famous fish from history as mammon. A trusted Central Bank (an awful oxymoron for a fish, as banks are never central in a water body...) creates these "Sand Dollars", which are valued for their durability and insolubility in water.

This is an awkward moment for me to intervene for another explanation, but what must be done must be done. Let's talk fish gender. The scientific names we have given to male and female fish are Genus Mascupisces and Genus Femapisces respectively. This is an international name used by all marine languages, though if I am correct, you do not currently have names to distinguish opposite fish genders.

Of course, we often refer to each other as Mascs & Femifish, or ladies & gentlefish, or girls & boys.

Three
Dolphornia Calling

"Live as if you were to die tomorrow. Learn as if you were to live forever."

~ Mahatma Gandhi

Proper training started a few weeks later. The Gilliams had moved to Clamton, Dolphornia, from Fishigan, a rigorous journey over a few days. Clamton presented fresh challenges. Adapting to the salty brine after years of sweet-smelling fresh water was difficult and tiring - the family had to take rests frequently because the salt was notorious for causing headaches, typically in the afternoons. Choppy waves often battered their tails, throwing off their swim rhythm, unlike the gently breathing placid waters of their former home. The currents were hard to swim against, and the simple act of even crossing the

underwater sea-stream proved to be an arduous task.

Fishard wanted to expose his children to the taxing lifestyle of those who didn't work hard (or were not lucky enough) to get a decent education and establish a career. Swimming around the fishdom, they saw littered streets, smoking teens, violent gangs and vulgar shacks. Their schools had changed, their old friends grew distant, and even their home, previously comfortably spacious, had turned into a small flat on the city-side of town. Worse still, many of the girls' things had to be left behind or sold off so that they could fit into their new home. Each girl was allowed her clothes, books, two pieces of furniture per room (including beds, pillows and blankets), their piggy banks, two stuffed toys, two normal toys, their school materials, their Bubble Ball equipment and three other things of their choice. Any extras would have to be negotiated with, and approved by, Mr. and Mrs. Gilliams.

The piggy banks didn't make it to Clamton, however. As Selena was making her laps from her room to her mother's (where the sisters had left their open suitcases splayed out on the floor), she saw her pink piggy bank peeking out from the top of the living room table, and rushed to grasp it. It was filled with exactly four sand-dollars, proudly earned after doing her chores in record timing.

She heard the zipper of a bag being pulled, and panicked: her mother was packing up already! She swam past her room to get the glistening Piggy Bank key from

the keyholder and swept past a clothes-carrying Neptuna. Neptuna was surprised, but managed to keep a hold on her neat stack as she made her way forward. It wasn't so lucky for Selena. Fins slipping, her Piggy Bank crashed to the floor, sand dollars skidding underneath the carpets and doors.

Each sand-dollar is currently worth about 2.32 human dollars (I can never remember which type). Don't bother with conversions, but what I can tell you is that the amount Selena earned (in your speak) and didn't want to give up was human-dollar 9.28.

Once Upon A Fishbowl

Pink pieces of broken, hardened jelly of which the piggy bank was made swam in front of Selena's eyes as red spots of anger sprouted on her cheeks. She had broken it... she had broken her precious Piggy Bank! As the rest of the family came out of their rooms to see what the commotion was, Selena flipped her tail in anger.

"It's not fair! It's not fair! Why did *my* Piggy Bank have to break?"

Selena shrieked, storming past to look at Neptuna, Lyndrea, Isha and Yetunde's perfectly shaped and glazed Piggy Banks. They were in the shades of lavender, mint green, sky blue and yellow respectively, and in a fit of rage, Selena smashed each and every one of them onto the wood-panelled floor. Being a toddler, her mother only had to pick her up and haul her away into the other room. Mr. Gilliams soon followed to reprimand her, and so it was an angry and ashamed Selena who had come to Clamton. The sisters were given small pouches to hold their sand dollars, but Selena was only able to find two of the rebel coins. Her mood didn't improve in the least when she saw her new room; it was as gray as the city around her. Her father had refused to paint it.

~*~

It was a Monday, the day they started training. The girls woke up to a blaring, turtle-sound alarm and just as the sea had started to shed light, they drowsily swam off to *The Right Fin Public School.* Six studious classes later, at three

in the afternoon, they bundled their bags back home and immediately changed from their dark grey and white school uniform into light Bubble Ball clothes.

Their practice court was in *Shipwreck Alley*, about a three minute swim from their new house. It was an old, mossy shipwreck shrouded in haze and dust. A loose patina of wood shavings encased the ancient ship, and sticky bubbles wafted out from beneath its sunken hull. Soggy, dilapidated boards hung precariously over the long masts and fishing poles littered the decks, smelling faintly of old, rotted meat. The surrounding rocks were scraggly and dark, and the flickering flag had a human skull imprinted onto it. From the cannon holes, thick sheets of oil and debris matted the water, stinking of pollution, and icy currents whirled around the stern. The oily consistency of the waters around the submerged ship made it eminently suitable for Bubble Ball. The place was also ideal for stamina build-up - the fishes couldn't stay there for more than fifteen minutes before going short of breath, which strengthened and enlarged their gills over time.

Their father was waiting for them and smiled grimly when he saw their stupefied, disappointed look. They knew immediately what was to follow in the coming days, weeks and months, and shrunk back in a visceral shock. The realization that a non-stop, strenuous, vertebrae-squeezing, gill-wrenching workout was in their daily offing drenched them in cold sweat (figuratively, of course, for fish don't *actually* sweat). The place was nothing like the glamorous, shiny Bubble Ball Academies that they had toured and seen

in countless of their sports magazines. Just as they gotten accustomed to one area of the ship, they would turn slightly to spot another challenge.

Mr Gilliams gave them a tour, even though it was futile. The girls had already realised how shabby and rundown the ship was. As Fishard started talking about their regimen, the girls looked around skeptically, lightly touching the thick globs of oily air masquerading as 'bubbles'. Their father picked up on it, and explained that the oil, in fact, was an extra incentive not to let the bubble pop on the fin or the body-side, for taking a shower at home after that would be a real drag due to the oily residue.

By the end of the week, they felt even worse. The wooden debris that floated around made them squint, and the smarmy bubbles drenched them in a mess of grease in every practice session; the oil left a flock of stains for at least a week! Sometimes, when they dove after a bubble, they dashed into the sea-bed which was, unlike like the bouncy normal courts, hard and spiky, giving them a few purple bruises that nagged them persistently. The scoreboard would keep floating away, taunting the girls by pausing, and then being whisked away just as their fins had grasped the tip. When that happened, the sisters had to race after it for a few minutes, and then sharply lug it back to their father.

The question they asked each other summed it all up in seven words: *Why don't we just* rent *another court?!*

"When you swim behind the plank, it gives you practice

in speed, and hauling it back just makes you stronger. The wood shavings will improve your eyesight; you'll soon see right through them. Girls, I need you to stop complaining. The Rent-A-Courts don't have side spikes, and only let you play for an hour. It costs more than it cost me to *buy* this shipwreck!" Their father insisted, trying to encourage them. He had bought the property right after arriving in Clamton (the wreck had originally been staked out by local authorities as a potential school yard area, but that plan sank once it was decided that no school would actually be built, *needing* a school yard area). He admitted that it needed a bit of fixing up, and part of his plan was to furnish, clean and paint the ship as a family project. Built character, he said.

Despite the seedy and cheap outward appearance of the boat, it was fairly spacious, and by the second week of training, the fish had cleared up most of the inside and marked out the danger zones with a quick border of spray paint. They replaced the flag and Mr. Gilliams sprayed the area with Anti-Pollutant spray, to evaporate the poisonous fumes. They covered up the cannon holes with thick rubber tarps and tied down the masts with plastic sheets and spools of rope. On the first floor - the second floor had rotted almost completely - they set up a small closet to keep extra fin grips, Bubble Baskets, two spare nets, and the excess tarpaulin, rope and binding plastic. There were two rooms on the first floor. The first one had a small kitchenette, where they stored some food inside an empty cupboard and stocked fresh bottles of water and Alli-Gatorade in the shelves lining the walls. They brought in a few old pillows and bolsters for

rest times, which were normally reserved for Mr. and Mrs. Gilliams, and cleared out a bench near the scrubbed window so that Mr. Gilliams could watch the girls play from inside the ship. The other room seemed to be a study, and there was a giant roll-out map that had been shredded into the table. In the corner was a smaller desk which they had repurposed for taking notes and learning sessions, and a whiteboard; these were normally only used on extremely dangerous days, when play was impossible. *Impossible Days* did not include rain, heavy wind, or even storms. For Mr. Gilliams, an *Impossible Day was* a day where lightning - flashes of electric current coursing through the salt water - was present, a sea-tornado or eddy was reported, or gang activity was high.

Mr Gilliams wanted as much time on court as possible. During lunch and sometimes even dinner, the family would assemble in the ship and eat there, watching the Sunset from the Sky ripple into the foamy waves. The ship also had a large clearing by the stern, and by lining the guidelines with sharp wooden sticks, and setting up a net with hanging mesh found on the boat, they made a Bubble Ball wall for single-player practice. The actual court was painted and lined right next to the sunken boat. A rectangular wooden plank served as a scoreboard, and every time one of the girls would win a point, Mr. Gilliams would scratch a mark with his sandstone pencil, and they would scrub it clean by the end of the day.

By the third week, Mr. Gilliams produced a shopping float-cart to hold the Bubbles and some whittled down stones for weights and exercises. He taught them how to twist algae

and seaweed into jump ropes and how to utilise the stones as tail strengtheners.

Along with the changes in their new home and court, they had to adapt to a remodelled version of their father. All of his previous leniency had gone, replaced with metallic, steel dedication to making his girls into Bubble Ball champions. Each day, rigorously, the fish trained. Bubble Ball was more arduous and severe than mere giggles in a lilting afternoon; you had to swim laps till your gills screamed, exercise till your fins numbed and play till your tail went limp. Their mother, who was also their Bubble Ball coach, would come and practice with them, and Isha, Lyndrea and Yetunde would join them.

Mr. Gilliams was also strict on routine. From day one, the rules were clear and the regimen set. On weekends, as soon as the light filtered through the waters, the young fish swam ten laps of the shipwreck, did twenty push-ups, twenty starfish jumps and thirty minutes of pure fitness training. Then they started practice on the various bubble-ball strokes.

Every day had a specific focus; forefin, backfin, slice, lob, spin, flat, forefin and backfin brush, down-the-line, crosscourt, swimming zone (and later, volleys, smashes, slices, no-fish-land…) Mr. Gilliams would explain the way to hit a stroke, when and how to hit it, and the purpose behind hitting it. He would then feed them the bubble, they would hit it back and then hit nine more. After switching a few times, he would start making the girls swim farther to get into position. Then

The way to jump rope underwater is to hold both sides of the rope in your respective fins and circle them around your head. This is what I believe humans do as well but we differ in the second part of the procedure. Instead of jumping over the rope, fishes must swim underneath without touching the rope itself, using it to propel themselves forward. It sounds complicated, but that is expected, as you are not a fish. Some professional-level jump-ropes are threaded with jellyfish sting (non-lethal, of course) to encourage faster swimming and stronger tails. And build character.

a few bubble-filled shopping-carts of serves, and some more rallying. It was only when their fins, tail, gills and hearts ached could they take a small break for lunch.

Post lunch, they'd have half an hour of free time and an hour for school studies. After that, it was back to the courts. For the second half of the day, they would play Bubble Ball with their mother and father, and sometimes their little sisters. They would finally finish with another twenty minutes of fitness and a fifteen-minute shower at home. Late evening brought relaxation, a chatty family dinner, some telefishion and bedside book-reading.

School days were less rigorous, but more tiring. They would have three hours of court time on general school days, and an hour Fridays as a small break. Once the girls had gotten old enough, however, these breaks disappeared.

After the third week, they bought a proper net, because the mesh was a not a very serious prop. While it didn't quite pop the bubbles, it let the bubble through at times, and against a forceful shot, it kept falling off the spokes holding it in place. The net was shiny and new, with no tears or rips that many often had. It gave an extra bit of joy to the sisters to play from the opposing sides of the dividing net.

The masts on the ship were old and had rotted, so Mr. Gilliams cut down some of the wood and got them made into benches and tables to place around the court. Yetunde and

Once Upon A Fishbowl

Isha also painted the court to look like an actual Wimbleswim Court, complete with separate colors and an umpire 'chair' which Mr. Gilliams occupied when the girls played games and matches. All in all, the place changed from the shabby, run-down shipwreck, into a cozy second home.

~*~

It was only on the last day of the fourth week that the girls started to learn smashes, volleys, slices, and other Bubble Ball hits. The water was sweltering, with elevated levels of brine and colloids. Selena had hurt her fin after bumping heavily against the ship's side, so her father had allowed her to take a few minutes of break to tend to her wound. After bandaging it using the first-aid kit in the cupboard, Selena drank a sip of water and returned to the court, where her father was conversing with Neptuna as she re-tied her fish-braid. It was quite rare for their father to stop and chat with the girls, even whilst explaining a technique or modification. He would normally shout out encouragement and criticism while feeding the Bubble, so that the the girls would learn how to think and react quickly. As she neared, she could picked up fragments of what her father was saying, and felt a spark of intrigue.

"... new... need you to focus.... technique... slices, volleys.... maybe even smashes..."

Selena put her bottle down on the side bench, rewrapped her fin grips, and hurried to her father, wiping off the stray beads of sweat gliding down her forehead.

Dolphornia Calling

"Selena, I was just explaining to Neptuna that I'm going to be teaching some new things today. We will start off with smashes and volleys, and once you're confident enough, we can work on your slices and lobs and drop-shots."

Selena, eager after her break, dashed to the baseline of the court, but frowned in confusion when she noticed her father shaking his head and motioning for her to get to the front of the court, where the net was.

"We'll be volleying first. Okay, I'm going to the other side, half court, and I'm going to feed you the bubble. Start lightly by just tapping it over. Start getting aggressive when you feel like it's too easy." Mr. Gilliams, was strict on shots and technique, but wanted the girls to have an open mind on when to hit passively and when, aggressively.

The first few bubbles popped right on Selena's fin. Volleys were hardest when the opponent sent them to you directly at a high speed, especially when you had to swim to the other side of the court to return it. As the bubbles were so delicate, hitting them on the Shine Spot (the strongest patch of the bubble) was vital. Mr. Gilliams was merciless - despite the fact that it was their first day of volleys, he hit bubbles high and low and across the court, so much that the girls fumbled and tumbled many times. Neptuna tried, and she was slightly better at controlling her fins then Selena. Earning a nod of approval, she sat down to rest while Selena swam back on court. The fifth time Selena missed it, Mr. Gilliams raised his voice, shouting above the pops.

Once Upon A Fishbowl

"Control! Control and guide the bubble, Selena! It isn't going to go over the net for you! Selena, CONTROL IT!".

During trainings sessions in the first week, this manner of speaking would agitate the girls, and confuse them, but they quickly grew to understand. The more their father yelled, the more motivated they got to improve their game, do better than the game before. It was even more motivating for each to know that her sister was playing better, because the friendly competition induced each of them to up her game another notch. Selena only felt proud when she had hit two volleys into the court in a row, and even then, it was only a tiny smile. High expectations were being built, and high expectations only.

By lunchtime, both girls could successfully hit a right-finned volley and back-finned volley into the singles court, and Selena had even started to back some power into them. Neptuna's were more calculated, landing squarely at the corner, or right by the net, or deep into the service box. Volleys could be placed in the wider doubles court (whilst playing doubles, of course), but Mr. Gilliams challenged them into only aiming for the singles court, and that too, on the sidelines. This demanded accuracy, controlled power and general focus in the game, and it taught them to play Bubble Ball smartly rather than with just sheer force.

Lyndrea had come to watch them half way through the volleying session, bringing a sketchbook and some drawing pencils, and by the end of the lunch, she had sketched and

colored a picture of the family playing (it was part of her homework anyway, and made a great display in the middle of the Gilliams' kitchen fridge.)

For lunch, they ate crunchy sea cucumber salad and crab sandwiches, but had to get home early as the waves had stated to become dangerous. Normally, they would play through any weather difficulties, but it was time to go home and do homework, so they decided to retire early.

When they came back, conditions were still unpleasant, but it was not as hot, so the girls practiced some serves and played a match. Neptuna won, utilising the day's lesson and coming forward to volley whenever possible, and Selena, who normally either won, or came close to it, challenged Neptuna to a rematch. Lyndrea had gone home, but Mr. Gilliams stayed to watch, note-taking and remarking between points, seated comfortably on the umpire chair. Evening had loomed up, but the girls were only two games in.

"Come on, girl, we need to go have dinner. It's a school night!" Mr. Gilliams finally said after receiving his fifth call on the phone from Mrs. Gilliams. Neptuna and Selena were bent over due to their non-stop exertion, elevated body heat pouring down their fins, their tails, their hair.

Mr. Gilliams didn't need a response; the girls had evolved from two little fishlings - frys - who had to be pushed to the courts. They were now two striving players refusing to leave.

~*~

Once Upon A Fishbowl

As he reflected on the day, Fishard had a flashback, thinking back fondly to the time when the two sisters were mere babies, when Selena and Neptuna were two and three respectively (funnily enough, some fish continue to think they're twins!). At that time, the family was heavily interested in Bubble Ball; Oceania was a Bubble Ball coach and Fishard was always trying to perfect his stroke by watching countless tournaments and matches. He vividly remembered the evening when the girls were first introduced to Bubble Ball. The couple had been watching the telefishion screen intently, while Neptuna and Selena played happily with a pile clamshell bracelets and coral gems. On screen, two great players, Darlene Hardshell and Althea Gillson, were caught up in an intense rally of lobs, drop shots and slices. Eyes still glued to to the bubble, Mr. Gilliams had called his frys over.

"Selena! Neptuna! Do you want to learn Bubble Ball?"

The little fish, who loved seeing Bubble Ball (even though they didn't quite understand it) had nodded happily, rushing to be first on their father's lap. Like a doting sports-father, Fishard had started explaining the rules to them so they could follow the game:

"So, for female fish, the object of the game is to win the best of three rounds. For example, if each fish has won a round, whoever wins the next round will win, as they have won two of the three rounds. In each round, you must win 6 games before the other person, but you must also be ahead of that person by two games. So, if you have won 5

games and the other fish has too, you have to win two more consecutive games before the other fish. In each game, you must get 4 points before the other player: 15, 30, 40 and Game. If both players get to 40, you must play more until you win by two consecutive points (called AD and GAME). Do you understand so far? Good.

So, to win a point you must be able to hit a bubble back to the other side of the court without it popping. If the bubble pops on your side of the court, the other player gets a point. When you serve the bubble, it has to go inside the opponent's service box. There are two boxes on either side of the court, and you must serve to the one diagonally opposite to you. If it doesn't go in, you get to try again. But just as your teacher, Mrs. Pearl, says, 'If you're out at two strikes, get ready for the spikes!'. If you miss your second chance, your opponent gets the point."

Selena, just a little toddler with a wide-eyed sense of discovering new words, had started to tap her father.

"What's an *oponit?*" she had asked, mid-tap. Neptuna had shaken her head.

"An *opponent*, silly, is like 'The Shredder', from Ninja Turtles. It's the fish you fight, since usually you fight the bad guy!"

Selena, by that time, was very confused.

"So you have to fight each other to win?" she asked her

dad, wondering why Darlene and Althea weren't fighting.

"No, no, of course not. 'The Shredder' is one kind of opponent, but not the opponent we're referring to. In Bubble Ball, the opponent is the person you are playing against."

Selena looked relieved.

She really didn't want to fight *The Shredder.* But she did want to play Bubble Ball.

She wanted to win against all *oponits.*

You may be wondering how the Gilliams family possibly managed to move from their nearly landlocked, freshwater lake to a salty, intercontinental ocean.

In olden times, it was an arduous and perilous journey. Inland fish in the Great Lakes would travel via the Saint Lawrence River on slow, slinky eels to the Cabot Strait. From there, they had to hitch a ride on heavy-bodied fin-whales, which swam enormous distances around South Americlam to arrive at Baja, Dolphornia, with one docking port at the Whaleport of Sand Fincisco. Then they'd have to book a seahorse to get to the local city of destination. The entire journey took

a good 60-70 days to accomplish, provided that the weather cooperated.

Over time, two developments significantly cut down the travel times. First was the discovery of a superfast species of fish - not known to humans yet - Genus Marlinae Concordia, in the family, "Istiophoridae". Concordia have been known to cruise at speeds up to a hundred miles per hour for hours on end. Their streamlined bodies and length enable them to carry nearly a hundred small fish nestled inside their skin folds and (for first-class passengers) the uncommon scales. Soon after the fish world had set up a symbiotic transportation relationship with them, long distances were within the reach of a few days at most.

The second development was the discovery of a vast network of underground wide-mouthed water-tube fissures, dubbed "fish-shers", which connected the Great Lakes, including Lake Nipigon and Lake Winnipeg. Winnipeg itself drained into the Pacific Ocean through these scattered

veins which meandered under Saskatchewan all the way to Seattle. The fishdom had found its own Panama Canal. The fish no longer had to use the extremely circuitous route around Cape Horn, powered by large fin-whales. As it is, these whales are dwindling in number due to large-scale slaughter by the thoughtless humans (no offense).

The Gilliams had taken a two-day ride on a scaleless *Concordia* via the Seattle Express to the newly built port at Clamton, Dolphornia. Their household chattel arrived much later via the old Whale-Express through the South Americlam sea-route.

One more thing: You may already know this, but weather systems are not restricted to the thin air above the water surface and on land. Oceans have their own vast weather systems. There are rivers, lakes, powerful currents, whirlpools and Eddies under the fairly gentle water surface above.

I'm not talking about Eddy, your pizza delivery guy but Eddy, a hurricane-like water storm. An Eddy is a vast swirl of ocean water circling and churning into a whirlpool for months. Its diameter ranges over tens of miles, and its sheer force can be damaging if the necessary precautions are not put in place. Unlike the above-surface typhoons

and hurricanes, Eddies are also a very helpful force of nature for the sea-world, dredging up enormous quantities of nutrients located deep under the water into shallower depths in the open ocean, sustaining the entire ecosystem, from phytoplanktons to the great whales. (So, in a way, it is quite similar to Eddy, your pizza delivery guy.) Without these massive rotating giants, we would not be able to continue living, so we keep large reserves of these nutrients should humans (yes, you) disrupt this cycle.

Similarly, ocean currents churn large bodies of water around in a uniform direction. This can be kickstarted via external forces such as wind, breaking waves, and what is known as the Coriolis effect, and they also help to keep underwater life healthy. Ocean currents contribute significantly to regulating the climate on Earth and transport carbon, nutrients and heat. As you may have heard, many of these currents have slowed down drastically in the past decade; this has a massive impact on our planet. Not only does it negatively

impact and affect us fish in our migration patterns, food, nutrients and fish distribution, it can kill off many of the species inhabiting the oceans, it also affects you humans. From studies which have floated down from your world, our scientists have gathered that freak storms will start cropping up more regularly near the coasts of what you call "North America" and "Europe", with colder winters and hotter summers.

Why is this happening? Because of you, again! Don't you feel *proud* to be part of the slow destruction of your only home? Scientists have noted that the ocean currents in the Atlantic Ocean have slowed down due to the sudden and large influx of fresh water coming from Greenland. Many of the icebergs surrounding it have melted due to global warming, and this causes huge deposits of water to cascade down into the ocean. Another source to cause your coastal flooding!

Global warming has many causes: some believe it is part of the natural process in nature. The vast majority of your scientists and researchers,

𝔉𝔦𝔳𝔢
Popping The Bubble

"Lightning makes no sound until it strikes."

~ *Martin Luther King Jr.*

At the age of twelve, when they first signed up for a tournament, Selena and Neptuna started preparations days in advance of the matches. These were quite involved and had to be done with meticulous attention. They had to clean their *'Xtra-Tite'* fin grips, work on playing consistency, braid and re-braid hair so it did not fall out during the match, and many such sundries. Exercise and healthy food habits were vital. Even the minor things like picking and washing a nice big water bottle and cleaning and drying the seal-fur towels were to be seen to very carefully. The whole family was pitching in, trying to make sure everything was ready, and if there was nothing

else to be prepared for, they watched matches on TV and practiced their strokes against a wall. Anything to shake away the nerves.

When the day finally came, the two fish woke up just as the water had started to glow a healthy orange. Bags were packed the night before, and fin grips were laid down on the couch, ready to be wrapped. The girls changed excitedly - Selena was wearing a light blue blouse and a white skirt, and Neptuna was wearing a peach top and gray Bubble Ball shorts. For breakfast, they stuffed their krill cereal down. Along with that, Selena had a river-banana, her favorite snack before playing Bubble Ball. Neptuna munched on a bowlful of saltwater cherries. It was essential to eat right before a match, and the sisters consumed everything their father told them to. This, unfortunately, included a bitter assortment of nuts and a slimy algae-protein bar. Their mother rebraided their hair, combed back the loose strands and then helped them mount their seahorses (with fin grips, it can be quite slippery, and painful to the seahorse.) Finally, after much excitement and preparation, they were off.

They reached the tournament half an hour before Selena's match. Neptuna, who was going to play right after Selena, was chattering excitedly with her mother about the new school that had opened up in town for serious, advanced Bubble Ball players. It was equipped with the latest in bubble-ball equipment, technology and materials, and had side spikes for each one of their fifteen courts. The two gillnasiums were designed specifically for Bubble Ball, and

the bubble machines could even play matches with you (they could auto-detect the bubbles and had many controlled-serve functions). The side spikes were real ones; shark teeth found near the bottom of the ocean floor. The tournament that the girls were going to fortunately had some side spikes made out of slate rocks found in the sea. They weren't very good, but for the time being, they would have to do.

Yetunde, Lyndrea and Isha were pouring over the newest fashion magazine. They were currently in the *"Finnings & Tail Extensions"* section, and they *'oohed'* and *'aahed'* over the dazzling pictures. They weren't allowed finnings yet, which were pretty pieces of jewelry that you put on near your head, near the ears. They were called finnings because it was very near to the fins, and whomever has heard of *"headings"*? Or even worse, *earrings!?* Meanwhile, Selena fiddled with her anemone-pink fin grips and watched the other courts, scrutinizing every move a player made, finding not just faults to avoid, but also moves and postures from which to learn. Neptuna mirrored her moves absentmindedly, examining her seafoam-colored fin grips for specks of dust.

The point system was quite simple: The first fish to win six games won the match. This was a much shorter version of "proper" matches, but designed to give rapid results and keep the audience interest engaged. For now, it wasn't stamina which mattered but sharp accuracy from the get-go.

The loudspeaker came to life and a fish barked out, "Court 3 has finished. No scheduled match." Immediately, a

surge of waiting fish rushed to Court 3 so they could practice, dragging Selena and Neptuna along with them. Neptuna immediately dashed over to get the court and managed to skid onto the starting line before the other fish. Over seven years of laps had earned her speed and agility. Selena swam to the other side, racing against the waves before another fish took her spot. She made it just in time, but when she looked over she could see that Neptuna was in a sticky situation. As her sister swam over the baseline, a yellow fin blocked her way.

"Sorry, but would you please move? We're trying to have a game here." A sickly sweet voice fell over Neptuna, and she looked up at the yellow fish. The fish was taller and probably older, and she looked like she could swat Neptuna away easily with her daintily finicured fins.

Neptuna frowned and said, "But you just came! I was here before you!"

The yellow-finned fish's smile faded and was replaced by a glare.

"Get. Off. The. Court." Her voice came out like a hiss and her next words were even quieter. "Nobody like you can be good at Bubble Ball anyway. You're just an ugly blue fish."

Seizing that opportunity, the yellow fish served a bubble to her partner, who had crept up from behind Selena moments ago. The partner hit it back with equal force, almost slapping Selena in the face.

Popping The Bubble

Neptuna watched with seething eyes as the two yellow fishes rallied, each effortlessly guiding the bubble over the net. She turned around, swishing her tail and engulfing the yellow fish in small, pearly bubbles, before swimming away. The yellow fish, trying to see through the spinning orbs, thrashed wildly, losing the rally.

"Hey!" she yelled as Selena quickly swam away to follow Neptuna, spinning her fins to create waves. The waves rocked over the yellow fish's partner, sending her floating into dizzy circles right off the court.

Steaming red and angry, the two sisters started to warm up, determined to show the yellow fish that they could win.

The loudspeaker crackled, emitting a fuzzy cracking noise, and a tired voice boomed out, "Selena Gilliams and Sheya Tailbyte, please proceed to Court 5. Collect your basket of bubbles at the counter located near Court Six. Five minutes warm up and then you must start. First to win six games wins the match. Sudden death at 40-all. Play a tiebreaker if the score is five games each. First to win five points in tiebraker wins."

Neptuna wished Selena luck as her sister swam boldly to Court 5. Selena collected the bubbles and smiled at the glistening orbs. She could see dozens of images of her face being reflected off the glassy bubbles. Still looking at the bubbles, she didn't notice the yellow fish behind her ask the counter clerk about the court on which Selena was playing, nor the sneer in which the yellow fish dressed her face. Selena

waited for Sheya at the court, still oblivious to who she was. It was only when Sheya had arrived on court did Selena's jittery nerves morph into fury. Sheya was the yellow fish from Court 3, the one whom she had sent away in waves.

After the customary round of teen banter, Sheya cracked her fins and fed one of the practice balls to Selena, hard and powerful. It popped right before it reached the net. Grunting in frustration, Sheya served another. It popped as soon as it touched her fin.

"She's hitting too hard. Her fin needs to be straighter so she can control the ball." Reflexively, Selena pointed out Sheya's faults in her head. Selena smiled slightly and Sheya, seeing this, thought Selena was mocking her. She then whacked the bubble straight at Selena's eyes and it popped with a sharp pang on Selena's face. A surge of pain bloomed over Selena.

"Court 5, please start your match. As we are running behind schedule you will not have any more practice time. Thank you."

The sound from the speaker died off and Selena glared at Sheya, still shocked at the intensity of the sting. Taking the sand dollar placed on a bench, she asked Sheya if she would like Heads or Tails. Sheya chose Tails, and Selena flipped the sand dollar, hoping for it to land in her favor. It didn't, and Sheya chose to serve first. Selena stayed on her side of the court, swishing her tail and warming up. She could do this, she told herself; all she needed to do was focus on

the game and not her opponent. Sheya shook her fins and reached into the bubble basket for the first bubble. The rules were that if you popped a bubble before serving, you lost that point automatically. As there was no bubble machine, they only gave you a certain number of bubbles.

Throwing the bubble up to serve, Sheya flicked it down onto the spongy service court. Selena played defensively, waiting for Sheya to get frustrated and make a mistake, but Sheya continued placing her shots into the court. They had rallied the bubble six times when Selena finally won the point. Sheya had hit a drop shot, with the bubble almost popping near the net, when Selena smacked it hard down the line and straight onto Sheya's fins. The bubble burst with a tired squeak. Quickly serving again, Sheya gritted her teeth and hit the bubble aggressively; Selena could barely keep up and she lost the point by the third rally. The score was 15-all and Selena and Sheya were already panting. Swallowing down her thirst, Selena waited at the baseline for another serve.

Sheya double faulted. The first serve bounced out of the court and the second one popped on her fin. The next serve, Sheya faulted again, and she muttered things to herself that Selena couldn't hear. Her next serve was a defensive one, and it allowed Selena to close in and smash. However, being trained by a professional coach all her life had many benefits, and Sheya lobbed the bubble over Selena's head and into the court. 30 all. Sheya won the next point, and although Selena tried hard for the next one, Sheya gained that point, too. Selena had lost the first game.

Once Upon A Fishbowl

The players waited at the benches on the sides of the court. After every odd numbered game, the two players got a water break. They sat opposite each other, gulping down filtered water and wiping their faces with seal-fur towels. At the start of the next game, Selena made her way to her side of the court, carefully picking up a bubble. With her tail touching the court, she served. (In Bubble-Ball, you must have one part of your body touching the line while hitting the bubble during a serve).

Soon, a rhythm set in for both players. Serves started finding their aces, rallies found their baselines, and smashes found their ways out. The two fish went at each other with all their minds and bodies, and the games went by until the score was 2 games for Selena and 3 for Sheya. If Selena lost three more consecutive games, she would lose the match. It was Selena's serve again, and she aced Sheya on the first point. On the next serve, she double faulted and then lost the third point as well. 15-30. 30-30. 30-40. 40-40.

Sudden-Death...

A sudden-death situation arises when both players are tied at 40-40. In normal games, a player has to win 2 consecutive points from 40-40 to win the game, which creates much excitement of see-sawing fortunes as players fight tooth and gill to deny a win to the other. Sudden-death is different, designed to cut short long games. From 40-40, one has to win a single point to win. So the game can go either way without a long back-and-forth of changing fortunes. The

game-life all depends on the edge of one point, so to speak.

Selena hated 'sudden-death'.

Serving, she readied herself to swim quickly for Sheya's return. Sheya hit a shot, aiming to Selena's left, but the bubble popped right before crossing over the net. Sheya smiled triumphantly, not realizing she had lost the game. Selena stared at her, confused.

"The bubble popped on your side...that was my point." Selena exclaimed. Sheya's smile vanished and she squinted at Selena.

"You cheater! That popped on your side!" Sheya Tailbyte swam up to the net, where Selena was waiting and pointed to the net. "It popped on your side." She repeated. Selena gaped at Sheya.

"That was clearly on your side. I saw it!" Selena protested.

"Well, then you're blind. Just re-do the point, Selena!" Selena shook her head.

"When I earn a point, I don't give it away. That was my point and therefore my game. The score is 3-all. It's your serve." Turning away, Selena swam back to the baseline.

"Wait. I'm calling the coordinators. There is no way I'm going to play a match with a cheater like you without someone to supervise!" Sheya spat out. Selena, hurt by the

fact that she was being called a cheater, raced to Sheya and said, "We'll go together then. That way, you can't lie about me!" They swam towards the counter and waited for the attendant to finish sorting out her papers.

"Are you girls done?" She asked cheerfully. Selena shook her head and asked if they could have a coordinator of attendant to umpire for them.

"She cheated and I don't want to win against a cheater. I want to win fair and square!" Sheya nudged Selena sharply, glaring at her. The attendant, not noticing the nudge and glare, told the girls to wait for a moment. She spoke quietly on a telephone, glancing at all the other courts and nodded slowly a few times to herself. Finally, she asked the girls whether they could play without a referee for a few points as the other attendants were all taken; the first matches of the season were always wild. Selena glanced at Sheya and then nodded.

"I think we'll be fi-" However, she was cut short by Sheya who said a loud, "No. I am not playing with someone who cheats like this. Honestly, it must be in your fins... being a blue fish, of course you're gonna be a cheater!" She said the last part under her breath. Remembering why she was there was all that stopped Selena from launching at Sheya.

"Fine. Give me a swimover then. If you can't handle playing me, then you can't handle Bubble Ball." Selena said.

The lady at the counter seemed not to hear anything

they were saying. It was probably because of the music she was listening to on her MyPod - they were the absolute *rage* at the time, as they were produced by a pod of whales in a company called *Pear*. Sheya glared at Selena and reluctantly followed her, muttering words like *"blue fish"* , *"stupid"* and *"cheater"* all the while.

The two argumentative fish made their way back to the court, and Sheya served. Selena won that game in four straight points, and she also won the game after that. Sheya seemed to have been completely rattled by Selena's aggression, and kept making mistakes. Selena would have won the next game too if it hadn't been for all the unforced errors she made. Her backfin wasn't very good in that game, and the bubbles kept popping on her fins. It was 5-4 in Selena's favor. The next game would either make Selena the victor, or put the match into a "tiebreaker".

Playing for all she was worth, Selena smashed, whacked, dropped and lobbed the bubble so hard that Sheya was on her tail the entire time, unable to take a breath. Selena had 3 points, Sheya had 2. 40-30 in Selena's favor. One more, and she would win...

Selena served, and as Sheya returned it long, Selena hit a forefin drop shot. Sheya raced to pick it up near the net, but the bubble popped on her pale yellow fin due to the steep angle of pick. The score: 6-4.

Selena had won!

Once Upon A Fishbowl

Flipping in victory, Selena beamed a wide smile. Sheya, kicking the sand in frustration with her tail, sulked away. *"Whatever. Stupid fish."* She muttered, and gathered her things, slowly swimming to her waiting mum. Sheya's mother wrinkled her face into a pout when she looked at Selena, scrutinizing her braids and flushed cheeks. She hugged her daughter possessively, as if Selena was about to rub off her blueness on her, but Selena ignored it. She had, after all, beaten Sheya, and although the icy glances stung, she kept her head high. It was only once the score lady had written down every detail that Selena felt the relief. She had done it! She had *won*!

~*~

"I'm assuming you won?" Oceania remarked, looking at her daughter's toothy grin. Selena could just nod, and her father patted her on the gills.

"I knew you could do it!" Neptuna said excitedly, jumping up and down. Her tail whacked away the fishizine she was reading and it floated away, the reed-pages fluttering in the waves. Neptuna, still bouncy and happy for her sister, swam after it. Lyndrea and Isha, who had stopped reading the fishizine, paused their game and hugged Selena, while Yetunde smiled and gave her a fresh towel and water bottle.

"When is Neptuna's match?" Selena inquired, wiping her face with the towel. Her skin burnt with the play's heat, and the towel did little to cool it down. Her father pointed at the clock.

100

Popping The Bubble

"Right about....now." And just as he finished speaking, the loudspeaker turned on, calling Neptuna and another fish named Lyra Clearwater. Lyra looked timid and lost as she stumbled towards the counter, but Neptuna swam confidently to the attendant, her tail propelling her forward and her fins swinging by her sides. They proceeded down to Court 2, which was out of vision for the Gilliams. Selena, hoping for the best, bounced around excitedly on the bleachers, watching the two yellow fish in front of her play. She recognized one of them as Sheya's friend. She was winning; but just barely.

An hour later, the tired Gilliams were speeding home on their seahorses. Neptuna, ecstatic about her first match, and first win, almost fell off three times, and Selena had to steady Jameka many times to keep a check on her sister. As they swerved into their swimway, Neptuna and Selena jumped off their seahorses and bounded home, trapped in an excited frenzy. Lyndrea, Isha, Yetunde and Mr. and Mrs Gilliams fed the seahorses some shrimp cubes and then hurried inside.

It had been a long but happy day for the Gilliams.

𝔖𝔦𝔵
Academic Matters

"There's no way around hard work. Embrace it."

~ *Roger Federer*

𝕷 ooking back on their lives, so full of rich experiences, one cannot but help think that *this was the moment* when the simplicity of their lives got tangled up in a long fishing-line. The Gilliams sisters' lives were soon to become an intricate, interlocking sequence of events and happenings. In retrospect, every other day of their vibrant life appears as a new story to tell, a new adventure they lived. To ascertain which were the most important ones is difficult, even for a fish-raconteur like me. However, many of these moments were long-lasting and impactful, and they boosted the two young fish to achieve the fame and glory that they have today.

Once Upon A Fishbowl

But! Let me restrain my excited seahorses, for I am getting ahead of myself. Let's reel in the fishing line a bit and track the story in steps.

After their first wins in that tournament, the two young fish gained immensely in their confidence and their joy in playing on court. They were more apt to listen and apply what their father had taught them, and through this newfound collaboration, they were able to soar to new heights. We must remember, however, how many fish were swimming toward the same goal of elite Bubble Ball mastery. In case you have forgotten... about a million.

Selena and Neptuna were learning how to play a game amongst thousands upon thousands of other such frylings and it was due to this fact that Fishard Gilliams decided to propel the girls further and faster. The answer was a professional Bubble Ball Academy. Despite the rocky history with Academies, this new one - *the Rick Mackerel Academy for Young Fish* - seemed promising. Not only had it steered plenty of players to fame, it had a foundation unlike any of the others at the time.

Learning through Experience.

Instead of classrooms with the fan on full blast circulating cold water and the chalk making squeaky marks on the board, pupils of this academy would be outdoors, playing matches and strokes against coach Rick Mackerel and other expert players. Tournaments and match-play simulations were hosted monthly, and courts could be rented for additional

time.

The sisters enrolled by sending a video to Rick Mackerel himself, showcasing the young fishlings' serves and shots. They hoped the videos would impress Rick sufficiently, and that he would invite them to join the academy and learn amongst the other aspiring athletes.

~*~

The water was clear that day. Selena and Neptuna remembered that, if nothing else. The mailfish was making his rounds, dropping off envelopes and packages (and, curiously, a shipping crate to the next door neighbors) while whistling a slightly off-beat tune. His satchel was filled to the top with letters, but that didn't signify anything, as there were many houses on their lane. Lyndrea, Selena and Neptuna were perched on top of their scaled mailbox, peeking around the corner and waiting to see the mailfish coming to deliver them the daily news, bills and hopefully a letter of acceptance.

He did come, but only to drop off a newspaper, a lighting and sound bill, and a letter from Mrs. Reef-Spoon, their teacher. Report cards were coming in, and it was a dreary process to look through your reports and comments, knowing that you could have done better. Selena slumped, losing all her previous cheerfulness and slunk back inside the house. They had been waiting for an hour, a long, tedious hour, and disappointment crested at their shrinking smiles. Neptuna followed soon after, finally convinced that the

Once Upon A Fishbowl

Mailfish wasn't coming back to deliver a forgotten piece of paper, stuck to the base of the satchel.

A shriek stopped Neptuna in the doorway. There was the sound of scuffling in the kitchen, and being slightly imaginative, Neptuna rushed to stop some miscreant robber-fish.

There wasn't a heist in progress, as she found to her relief. It was just Selena, clutching something peach to her chest.

"He sent it! Dad went to the Academy and got the letter!" Selena sped around the countertop in circles, knocking over a jar of salt-berry jam in the process. Selena bent to clean it up and Neptuna caught the floating piece of paper.

To the Gilliams family:

Congratulations! Selena Gilliams and Neptuna Gilliams have been accepted into the Rick Mackerel Academy for Young Fish! Training shall start next Tuesday, March 19th, and we look forward to seeing our new additions! Enclosed in this envelope is a booklet for rules, guidelines, payments, tournaments, other information and FAQs.

Academic Matters

Selena and Neptuna shall be trained by Rick Mackerel, on Court 7. The facilities you requested were Bubble Machines and Courts, which fall under our regular slot. There will (ideally) be two classes a week, and if possible, for the duration of two hours each. Timings shall be discussed with Mr. Mackerel himself, and more information shall be provided in the booklet enclosed.

Welcome to the Mackerel Family!

Sincerely,

Abby Lotusfeld

Secretary for: Rick Mackerel Academy for Young Fish

The two girls and the rest of the family were absolutely ecstatic! Not only had they gotten admitted to the academy, they were to be trained by Rick Mackerel himself! The booklet was just as enticing, with photographs of shining, translucent bubbles bursting into a winner, and trophies and cameras, propped up for tournaments. There were snapshots of banners and large posters, and close-ups of thin, tall side spikes. Actual side spikes!

Once Upon A Fishbowl

The excitement hadn't died down by the appointed date of Tuesday, March 19th. Determined to reach on time, they left their house almost an hour early. They spent the extra time looking around the campus, taking in the simplistic walls, the elegant tables and the small structure. Unlike the academy they had tried to previously enroll in, this building was a simple two-story building circumscribed by playing courts. It was cozier and more effective than the Bubble Ball Coaching campus, and was primed with informal, smiling photos of the coaches and players. There was a trophy cabinet to the side, elegantly lit with glowing masses of bioluminescent bacteria. The courts were painted and swept clean. The expansive nets seemed fresh, and tightly knitted, but the best of all was the Bubble Machine. There was one massive Machine to the side, and players ran up with a bucket for the Bubbles to be dispensed in. Some people were playing; there was even a match going on in one of the courts, and it truly was the perfect picture of the great game of Bubble Ball.

"Hey! Are you the Gilliams sisters?" A voice called out behind them, and the family turned around.

"Oh, great! You're here early, I can give you a small tour!"

It was Rick Mackerel. He had three fin grips in his fin, and he shook their fins with the other one warmly. "It's so good to have you here!"

The Gilliams family could not stop smiling silly, as anyone

would on such occasions.

"So, first of all, we need to sort out your fin sizes. We have five different sizes, but I brought three which I think might fit you."

Neptuna was able to fit into the slightly bigger green pearlescent one and Selena took the lavender size. Mr. Mackerel slipped the orange one into his pocket and then swam forward slightly, motioning for them to follow him. He swam back to the lobby area and gave the three older sisters a booklet and one each for the parents.

"This here's the lobby; you can do pick-ups and drop-offs here. The room on the right is the kitchen. That's mostly for the coaches, but if you're ever hungry, I'm sure we can find you something. The Gillnasium's to the left."

Neptuna and Selena looked at each other with wide eyes. This tour seemed awfully familiar, but it was in a completely different context.

"There are seven main, outdoor courts here, three for match play and four for practices and classes. The Bubble Machine is located right at the end. Each court has a big bucket and you can fill up to hundred bubbles in the bucket at a time, so that's extremely helpful for drills. I think that's about it! Would you like to start class?"

They started immediately, taking their positions.

~*~

Once Upon A Fishbowl

It had been two weeks since the start at the academy, and already they were gathering an informal fan following. Fish from the neighborhood would swim by for an hour - some swore by Neptuna's calculated and consistent shots, while others were more aligned with Selena's aggression and power. Most, however, were just excited about these two new prodigies. The courts were lined with slender wire fences and meshes, with posters hung up on some and scoreboards hanging from others. There were little clapboards hanging by the nets as well, to display the number of games won. Every practice, there would be at least one fish on the other side, face pressed to the fence, eyes scanning the bubbles. New arrivals always held interest in the crowd, and people were fascinated with the fluid movements that the Gilliams sisters showed. Sometimes, when other players were taking a break from their own class, they would watch the two sisters, sipping water in slow ripples. There were all types of fish: the timid, blue Shoal Stephens. The tall and thin Maria Sharkapova. Redheaded Miles Coral. Bucky Van Der Kelp. And whether they showed it or not, they definitely were impressed with the agility, the endurance that Selena and Neptuna had learned during their countless hours in the shipwreck.

Rick Mackerel, still smiling and cheerful, was just as hard of a coach as their father. He would make them go through the drills again and again, until they could practically tail-juggle bubbles in their sleep, and when playing points he was so ruthless that for the first month, the longest rally was four shots. The girls got better though, and watching them play

against their coach was almost as entertaining as an actual tournament (which they played more and more). Even running to get bubbles had to be fast, and they were timed. They had to balance the hefty bucket on their fins while running back, and if it spilled, they had to swim ten laps. Their father stayed to watch them for the first few weeks, grunting in satisfaction when a shot went right and slapping his tail on the ground when it went out. Oceania, on the other hand, watching with quiet and cool contemplation, briefly nodded at the aces that the sisters hit and clicked her teeth if they double faulted.

The schedule of the class was different as well. They had a two-hour class every Monday and Wednesday, and the remaining days were spent training with their father. Their typical training session included 15 minutes of warm-up, 30 minutes of drills, a 5-minute break, 10 minutes of feeding the bubble and hitting back, 30 minutes of match-play drills and 30 minutes of actual match-play, which went on longer if nobody was using the courts. Luckily, Mr. Mackerel had a rest slot in that time, and did not have to attend to another fish. It was during this matchplay that the curious faces would start peeking in. Some fish had even started bringing along their cameras to take pictures and videos, posting and sharing them on the Hydronet.

The Gilliams sisters had indeed been propelled forward.

They were about to change Bubble Ball forever.

Seven
Starfish Rising

"Success is a lousy teacher. It seduces smart people into thinking they can't lose."

~ *Bill Gates*

1997. Another year in a regular sequence of years which fall like dominoes, dutifully and eventfully; no different than the the ones preceding it, similar to the years that were to come, but a year of importance nonetheless. It is funny how every day, every week, every month is perceived differently by different fish; for some, a split second might be a turning point, a direct shift in their lives. For many, it might be a stepping stone. For a few, it may be the first moment of something electrifying experienced, and for still others, it might be the last...

Once Upon A Fishbowl

1997 was no different. The same tangling of swordfish in some shoal, a few shark attacks, sinking plastic debris from the careless world above, some scares with the fishing nets... The human world, one hears, went through similar sorts of moments. A car company released its newest edition of a sports car; a famous watch brand hired a Hollywood influencer as a spokesperson; another batch of students graduated; a war somewhere in the world was started over trade issues; stock markets in some places rose and in many others, collapsed like a house of cards. Run of the mill year.

But for Selena Gilliams, this was a milestone year...

~*~

The water felt heavy and cold, and the waiting room seemed alien to Selena. It was a new experience, this waiting before a match started, and a professional level match, to boot! Selena had qualified for the second round in the 1997 Americlam Cup, having defeated a highly ranked fish, *Jelena Lemon-Tetra*, in the first round without dropping a set. It was a new experience for her, to overcome a very strong opponent, and she was nervously excited.

Seated a few slatted benches in front of her was Mary Pierce-Tooth, a confidently accomplished player who ranked seventh across the seven seas. Selena tried not to think about it. As her father used to say, half the battle is with your own fears, and the sooner you overcame them, the faster you could face the outer challenges.

Starfish Rising

To while away the nervous hour, Selena was stretching lightly on her tail, braiding her hair, wrapping her fin grips and refilling her water bottle. It was a calming practice, letting the water take your body. Selena had released control over her fins, swaying gently in the cool liquid. She could hear the buzz of the crowd, and she knew that somewhere out there was her family, and her coach, and a multitude of fish waiting to see her. Fish *wanting* to see her. Mary sat rigidly focused, well-versed in the practice of contemplation and readiness, and she merely nodded quietly to herself every time an amplified shout of "MARY!! MARY PIERCE-TOOTH!" reached the changing room. The crowd was biased and had its favorite; Mary was popular and known in the games of Bubble Ball, and Selena was the underseal; excellent, but on an unsteady slope without wide recognition. Selena didn't mind. Her main focus was playing, winning, and winning well.

The fuzzy voice of the announcer blared out, "Match starting in fifteen minutes. Please take your seats."

Selena washed her face (yes, fish wash their faces. Just because they are surrounded by water doesn't mean that the water is clean) for the ninth time, and ran through her strokes in her head. Mary was a player skilled in rallies, and the faster Selena could finish off the point, the better. Last week's training had a primary focus on striking aces and trick serves, and tiring the other player out, so Selena's approach was going to be more skill than raw strength.

Once Upon A Fishbowl

"A *ballet*, not a boxing match!", her coach had admonished her.

It didn't mean she wouldn't use it, though. Her austere regimen had built up her muscles and power, which were proving to be two of her greatest allies when it came to Bubble Ball.

An attendant swam in, followed by a gang of fish who hastened to tidy the changing room. One carried a pack of oxygenated kelp-water bottles made of biodegradable organic material, and offered three to each player, while another carried a stack of white, fluffy anti-brine towels. Each player took two, carefully placed them in their bags and hefted them up onto their fins. Another attendant guided them to the courts, where they waited underneath a shaded panel for the match to begin. Selena could see some of the crowd, milling around their seats and sitting down, waiting to see the players emerge on court. The box in front of her was almost full, save for a few seats stuffed with bags and posters. They were playing to a packed house on the center court, with barely a chair or two empty.

The umpire tapped the microphone: "Ladies and Gentlefish, we will be starting the match soon. Please take your seats."

Mary straightened up.

"Please welcome, Miss Mary Pierce-Tooth!"

Starfish Rising

The crowd went wild, screaming and bobbing into the sloshing water. Mary's bench was on the other side of the court, the side Selena couldn't see.

"And, Miss Selena Gilliams!"

The crowd erupted into applause, excited to see the promising new player. Neptuna, too, had recently played a match, winning in two sets, but the crowd had yet to fully see her sister's potential. There was anticipation in the crowd, and the tickets had been flying out of the ticket-booth much in advance.

Selena swam over to her bench, laid out her towels and water bottles, checked her fin grips and finally looked out at the crowd. It was dizzying. Overwhelming. There were colors everywhere, illuminating her eyes. There was the white from a kid's spilt ice cream, deep red from the shirts of a group of six fish, screaming and yelling incomprehensible things. The flashing black and yellow of cameras and phones, and the rippling blue of the reflected Sky.

Selena calmed her gills and took a deep breath of water. There was a crescendo of sound outside, and a gentle warmth of peace inside her.

"C'mon Selena!"

"Ma-reeeeee! Ma-reeeeee!"

"Fall-down" is a term we use to describe one of many things: sudden collapse or crumpling in a time of hysteria or amnesia; mental falls in which a fish tends to forget what has just been said; a quick stumble over imaginary things (or as some seem to call it up on land, falling over your own feet); on very rare occasions, tripping "head over tails" in a disreputable love. The latter was created as a result of the escapades of the infamous Swimmy and Clyde duo, and has ever since been used as a slang phrase in the fishdom.

Starfish Rising

Selena, ignoring all the racket, fetched a bubble from the bubble machine to start her warm up.

The match started.

She aced it on the first serve.

~*~

"Selena. SELEna! SELENAAA!!!" Neptuna was finding it hard to calm down Selena, who was a mess of smiles and tears and hugs and, strangely, sudden *fall-downs*.

Selena had won. To keep things tidy and short and simple, though things rarely are, Selena had won in two straight sets. The first one was surprisingly a breezy current, while the second was slightly more difficult. The second set ran into a tiebreaker, of which Selena quickly took control to finish the match with an astonishing lob over Mary's reflexive volley. The final score read: 6-3 7-6 (7-3).

A win like this was bound to be exciting, and the only thing that could actually clamp Selena's mouth shut was the fabulous dinner (consisting of things I cannot describe to you because the family finished it so fast). The sisters had decided to switch to a mainly vegan diet of sea plants and krill.

Trust a father to water it down on such occasions, I always say. Spray squid ink on someone's parade. On cue, Fishard Gilliams cautioned her in his serious tone:

"You have another match, Selena. This match was nothing, not noteworthy, not praiseworthy, not memorable. Do not get carried away in your overconfidence. You should only celebrate once you've actually achieved something."

Fishard Gilliams wiped his mouth with the napkin and set down his fork. Oceania looked at him, in that hard way that only mothers can when they're trying to convey a secret message subtly but don't realise that it's too obvious to be considered either subtle or secret. It usually comes across as a proclamation.

Krill is not meat.

Whatever you may say, krill is not meat, and is as 'meaty' as you would consider a mushroom. Alive, yes, but then again, so is a mushroom!

Starfish Rising

"I think you need to keep working this hard. I'm proud of you." Oceania gave Selena's fin a high five. She started to clear up the table, setting jars of sea-salt back and throwing away stray tissues, and the rest of the family mingled around to help. It was peaceful moments like this that really made you love the Gilliams' family.

~*~

"Fifteen-Love".

Selena stared back hard at Monica Seals. Monica was serving again, and had just aced Selena. Again.

The score was: 4-6, 1-3. Selena was down a set, but ahead by a broken serve in the second.

Monica had won the first set, and Selena had twisted her tail in a knot, urging herself to win the next set. She was doing fine, wiping out most of the points with slick placements of the bubble and sudden frenzies of powerful, dominating lobs, but it was clear that she was tired and panting heavily. Monica was in a similar position of discomfort, and she shifted ever so slightly to the front.

"Net! First serve!", the umpire called out as Seals' serve bounced in, just grazing the edge of the net. Selena hovered up and down, wiping out stray hair from her face.

The crowd was silent as Monica served, and Selena returned it with a stressed backhand. The rally continued,

with both players scrambling around the court. Monica hit a sudden drop shot, the bubble floating down in slow motion. Selena raced to pick it up, and a flurry of volleys followed, only to have Selena net the bubble in the end.

She flicked her tail on the court in tired resignation. It was a tiresome process, Bubble Ball. And with so many players vying to get to the top, it wasn't easy either.

So by the time they finished the second set, which Selena cleaned off with an easy 6-1 win, both the fish were frantically sipping water and circulating their fins. Their first anti-brine towels were drenched in salt, crying out for fresh ones. The precious break of three minutes was vital - every muscle, every nerve in their body needed to be replenished and re-energised.

And then, quite quickly, the umpire called the players back on court again.

The third set was over before it started, it seemed. Before a stunned crowd, Selena had wiped out the *fourth-seeded player in the world*. No one would have anticipated this almost unranked player - Selena was ranked 304 in the ocean-rankings - who had entered the competition as a "wild-card entry" and allowed to play only at the discretion of the organizers to take out two top-ten players in two nights in Bubble Ball.

This was incredible stuff - Selena had just become the lowest ranked player *ever* to defeat two top-ten players in an

international tournament…

~*~

I don't know if you're tired of hearing about Selena winning. It's only been two matches which I've explained, skipping over a whole truckload of others. It is important to note, however, that Selena would carry on winning; not just carrying off trophies and fame but also laying claim to many golden Grand Clams.

But we are, yet again, getting carried away in the ocean current of her life story too fast so let me slow down.

Selena faced challenges in her quest, as any great fish does, and one of them was losing. Selena did not win the Americlam Cup that year. After a hard-fought match against Lindsay Divingport, seeded fifth, she had to return home with a loss.

Over the years, Selena lost many times. Sometimes to better players, sometimes on off days, sometimes from body fatigue. She never liked it, of course, but losing built her determination, her fortitude, her drive to excel further, and ultimately inculcated a serene acceptance of her place in Bubble Ball history. Losing may look like the greatest nemesis of a Bubble Ball player, or for that matter, any sportsfish, especially in cases of extremely competitive ones like Selena. However, despite the bad reputation losing tends to receive, it has many virtues, if you can view it dispassionately and analytically. From a detached distance.

Once Upon A Fishbowl

There is no such thing as a draw in Bubble Ball. There is always a winner. And, consequently, a loser. However losing is part of the long journey, and what reflects your character is your reaction to the loss. As the saying goes - apocryphally attributed to the great philosofish, Winstone Churcheel,

"Success Is Going from Failure to Failure Without Losing Your Enthusiasm."

Starfish Rising

Eight
Divine Spark, Divine Conflagration

"Religion. It has given people hope in a world torn apart by religion."

~ *Jon Stewart*

Phew! This has been heavy going, and I know you want to surface for some air. But let me detain you for a tweedly bit more before getting on with the story because I'm angry, and when I don't let the steam out, I blow up like a pufferfish.

I want to supply you with some facts and go on a small harangue against my own kind and the ills afflicting my submarine society, because it is bothering my gills to no end.

127

Once Upon A Fishbowl

I want to address the whale in the aquarium swimming in the undercurrents of Selena's story. You should find this relevant because you, dear reader, are struggling with similar problems in the Overland. If you aren't interested in hearing my speech and want to skip a chapter, there is nothing I can do to stop you. This book has travelled beyond my possession, away from my little cave where I, bespectacled and (to be very honest) sleep-deprived, have been writing this narrative and mixing up my tenses. You have the power to choose. You even have the power to put this book down and swim away. However, I would advise you not to.

Really. Don't. Remember in the words below: you have the power to choose.

~*~

The United Shoals of Americlam is an exceptional expanse of the ocean. The fish society here have adopted a governing Constitution which has steadily guided it over the course of a few hundred years to approach principles of equality and open opportunity. It is a common idea to speak of the *"Americlam Dream"*, signifying waters of unlimited opportunity, of tides of fortune which favor all who wish to catch the surf. Fish from around the world migrate to this nation, crossing the waters legally and illegally, as circumstances dictate.

By no means has the creation of this state been a smooth ride. It took nearly a hundred years after the Constitution was adopted by the United Shoals for slavery of blue fish to

Divine Spark, Divine Conflagration

be made illegal and all slavefish to be declared free through the historic *"Emancipation Proclamation"* by one of the greatest presidents in the Shoal's history, *Crab Lincoln.* Just a hundred years ago, female fish did not have the right to vote and make their voices heard, till an Ocean-wide movement on *"Suffrage For All"* led to changes in the system. And up until less than sixty years ago, blue fish were subjected to segregation and discrimination by the dominant yellow fish under the *'Jim Kelp'* laws based on the feckless doctrine of *"Separate, but Equal"* ... We saw this in the stories of Rosa Sharks and Marlin Kingfisher Jr. which Fishard Gilliams used to read to the Gilliams sisters. The end of those segregation laws did not mean that the yellow fish changed their minds overnight. Social change takes time and energy. Minds and gills are slow to adapt from old prejudices. It has taken a long time for matters to evolve, and despite what many say, fishism is still quite common today in Americlam.

The Gilliams Family, being blue fish, had endured discrimination both subtle and overt, but they had powered through that with pluck and maturity. Matters were compounded for them, for not only were they blue, they were believers and followers of *Jehovah*, a mythical Mermaid of divine origins. They were thus called *"Jehovah's Witnesses"*. And that was not always the easiest of burdens to carry.

Mermaids...

Mermaids are a tricky subject to talk about because they quickly give rise to heated arguments and debates, not only

on the nature of their existence (or non-existence), but also their powers, teachings through various Holy Books, their favored groups of fish, their Prophets and Emissories, and more. (I've got to swim carefully here and choose my words wisely, or there will be a group of offended fish banging on my front door as soon as this paragraph is out.)

Mermaids are typically considered to be "protectors" or divine beings watching over the fish. They are considered to carry the *'divine spark'*. This would not be so controversial except that different groups of fish all lay claim to worship *"The One True Mermaid"* (TOTM), and of course, everyone's TOTM is different from everyone else's TOTM! Some believe in Mermaid *Seesus*, some in *Coyshen*, yet others in *Causeweh*. Some hold the staunch belief that Mermaid *Shellah* had created the Primal Ocean, and some "know it in their hearts" that Mermaid *Seava* is the one true Almighty. Some don't even worship a Mermaid, and lay their trust in the sciences. There are a myriad Mermaids to choose from, and each side holds steadfast in only the philosophy *it* preaches. Due to the lack of substantial evidence (apart from seeing Mermaids in dreams), no fish can argue over who is right without running into a roadblock, and that's why this debate has continued over thousands of years. In many places, fish of one denomination cannot visit the shrines of another. Every Mermaid seems to have marked Her waters.

Due to the sheer importance attached to a Mermaid as "Creator", many believe that it is wrong to even acknowledge anyone other than their own TOTM. The proliferation of

Divine Spark, Divine Conflagration

this "Mermaidism", disagreements over the true nature of the ultimate Mermaid and the associated intolerance frequently spill over into heated arguments, suppressions, riots, mermadic crusades, inquisitions, wide-scale slaughters, wars and unspeakable bloodshed. No fish of any hue is immune to this deep religious malaise. Throughout history, terrorism and fear-making have been prominent aspects of religion. Though the spotlight has been on *Musselims*, most religions have had their fair shares of violent fanatics and believers. The Crusteans had their Crusades a few centuries ago. And who can ever forget the genocidal Shoalocaust of Jewfish, wrought by Fishler - a dreaded name spun of evil and malice? Surely no Mermaid would condone such behavior! But then, one does not logically argue theology with a fanatic fish without risking a chopped tail, it seems.

Atrocities like that should never happen again, and yet, they do with alarming regularity. History shows us the true depths of evil to which a fish can dive, and yet, we stay myopic in our barrier-building, raising our walls of exclusion.

We cannot be friends if you are a Morwong fish.

We cannot be communal if you're impoverished.

We cannot love if you're of a low caste.

We cannot… if you're blue.

If you're purple.

If you're Spanish. Indian... African...

Once Upon A Fishbowl

The list carries on, stereotyping every aspect of our sea, every angle, and the crabby onlookers cannot help but imagine how blind fish can be.

Ask ourselves: What really makes us special? What gives us our strength, our vibrancy? Is it not the diversity of thought which explores so many facets of the rich nature which cocoons us? If it's our differences, then why do we hold negative and self-destructive consequences for those differences? And if we believe in our oneness, then what's the point of harping on those artificial and not so artificial differences in the first place? Why exaggerate them, imbibing subconscious discriminatory behavior within ourselves? Why create *lava camps* to kill off groups of minorities? Why stunt their growth through oppressive means? Are they any less in a Mermaid's eyes?

Apologies, for I digress. But I digress only slightly, just to prove a point. The stories of Neptuna and Selena can be paralleled with so many aspects of our lives, that it's impossible - no - unforgivable, to ignore these social issues of monumental consequences. If given the opportunity to write about, speak about, do something about the consequences of our actions, one should take it. Just as I am doing now. As my clownfish father says cynically,

"Suspended somewhere in ether...
all good intentions."

He is right.

Divine Spark, Divine Conflagration

It is our job to prove him wrong.

I am in no way trying to smother the Gilliams' story with preaches, which is why I limit myself here to a few notebook pages of writing, but it is important and significant to highlight these issues. I plead, with these last sentences, that you do something in any small or large way, to make a difference to your surrounding shoal. As one of our Senator and Attorney General, Bobbing Threnody, once said:

"Each time a fish stands up for an ideal... she sends forth a tiny ripple of hope, and crossing each other from a million different centers of energy and daring, those ripples build a current that can sweep down the mightiest walls of oppression and resistance."

One fish can only swim so far. But collectively, we can change the course of the Ocean.

𝔑ine
Tell-Tail Tales

"Falling down is an accident. Staying down is a choice."

~ *Rosemary Nonny Knight*

T he glow of the computer screen lit up Selena's sinking face as she scrolled down the rankings.

"I've slid down below a hundred?!" she whispered to herself in a shock. It seemed as if the over-powering blue glow of Selena Gilliams had finally diminished, to the relief of her rivals, and to the sorrow of her fans.

She was in Neptuna's room, where Neptuna had fallen asleep on the quilted bedspread, and the clock was climbing slowly up to midnight. Selena woke Neptuna up.

Once Upon A Fishbowl

"Neptuna! NEPTUNA! Wake up!" She whispered urgently. Neptuna, unlike Selena, was calm and quick while waking up, but nevertheless, yawned, mumbled and asked drowsily,

"What is it?"

"One, you're not allowed to sleep before me, and two, I'VE DROPPED TO 130th PLACE IN THE RANKINGS!!" Selena, still whispering, spoke loudly the last part in verbal capitals, and Neptuna quickly 'shushed' her.

"What rankings?" she asked sleepily, sinking her head back into her pillow.

"WBBA! The Women's Bubble Ball Association! Neptuna! Stop sleeping!!"

"WBBA? Oh... don't worry. You've recovered from your injuries so you'll be able to get back up there."

"Yeah, but what if I can't, Neptuna?"

"You can! Tomorrow, I'll ask Dr. Drumshell if you can sign up for a tournament. Then we'll practice really hard."

"Not Drumshell! It's Dr. Clamshell! And I can't sign up for a tournament yet because he said I had to wait for a few weeks. And by then, I might even be in 200th place!"

"Calm down Selena! You'll make it back to top 10. And you'll get past that to become top seed."

Tell-Tail Tales

"But…"

"Selena, you have a goal. You have intense dedication. You have fierce determination. Those are the things which make you such a great player! The only thing missing is your presence. Just boost up your self-confidence and believe in your old self. You're… already… halfway… therrr…-" Neptuna had fallen asleep. Again.

Selena, feeling dubious and uncertain, started swimming out of the room. "Thanks Neptuna. Good night."

Neptuna nodded in response, already dreaming. Selena swam to her room and slipped into her soft bed, uneasily wishing that the next day would arrive so she could start practicing.

A top ranking place was a long way away…

~*~

Every player of a professional calibre feels invincible, with a subconscious assumption of having been endowed with a divine armor or talisman to ward off all physical challenges. High-octane fitness regimen, regulated diet, specialist guidance and fluid training gives one an aura of invulnerability, of being able to take on the world effortlessly for all days to come.

Till of course, one of those days comes…

Once Upon A Fishbowl

It was January, 2006. Selena was the reigning champion of Ospreylian Open Sea, but when she entered the tournament, it was without all her heart, all her winning will. Something had been changing. The 2003 death of her sister, Yetunde, in a gang-related random shootout had weighed heavily on her mind for long. She had also developed other career interests besides Bubble Ball, with forays into fashion apparel and cosmetic lines for fish, and a desire to act in Shoallywood movies. To top it off, she had started suffering from niggling pain at the base of her tail, a warning sign her body was giving to slow down. All of these took a heavy toll on her psychologically. In her own words in the biography she wrote a couple of years later,

> *"All I could think was that I so didn't want to be there, at just that moment. On the court. In Shellbourne. Fighting for points I didn't really care about, in a match I didn't really care about. So what did I do? I cried. Right there on court... it was such a low, despairing, desperate moment for me."*

(source: Serena Williams & Daniel Paisner, "My Life: Queen of the Court")

In the third round of the tournament, Selena lost to the seventeenth-ranked fish named Danyella Anchovy. Subsequently, Selena withdrew from the 2006 "French Fry Open Sea" and "Wimbleswim" tournaments, amongst others, on her doctor's advice.

Tell-Tail Tales

She was out of Bubble Ball action for many months, recovering from all the things which were afflicting her...

Her Bubble Ball ratings went into a free-fall, which created much anxiety for her; anxiety and worries for the future, despite having achieved so much in life already...

~*~

Lyndrea Sand-Dollar swam into the golden-white clamshell house which Selena and Neptuna shared. The girls had moved out of their original house a few years back, and had redesigned one in Fishida, on the other side of The Shoals. That way they had more space and time for training. The clean, white walls were silent and observing, and the peaceful whistle of the wind was the only sound Lyndrea could hear. In the living room, she could see family photos hugging the shelves and walls. Swimming slowly through the house, she bumped into Neptuna, who was eating some breakfast in the pearl-themed dining room. Neptuna smiled and pointed to a room on the right. She finished chewing and said, "Selena's in there. Do me a favour and wake her up for me. It's already 8:30!" Lyndrea nodded and went quietly into Selena's room. The blankets were swaddled around a sleeping Selena and Lyndrea gently shook her awake. Selena was slow at waking up and she groaned as Lyndrea opened the curtains. Beams of sunlight spilled onto Selena's face and she drowsily opened her eyes.

"Hi!" Lyndrea said, sitting on the bed. "How's your tail? Is it still hurting?"

Once Upon A Fishbowl

Selena nodded, moving her tail slowly.

"The doctor said my tail would hurt the most, but it might affect other parts of my body... I wish I could play Bubble Ball!"

Selena got up and came out of bed, swimming towards the kitchen. By now, she could slowly propel herself, instead of needing assistance to go to the bathroom, eat meals and get to wherever she needed to get to by Neptuna.

"At least you're able to swim now. Neptuna's in the dining room. It's 8:30."

They went to the kitchen to have breakfast and as Selena prepared her lemon balm cereal and cabomba-toast, she and her sister talked about Selena's injury.

"Which cereal do you want? We have afzelii flakes and sugar crystals, but you can also have fruit skewers... we got a package yesterday." Selena asked Lyndrea, pointing to the various tins and cardboard boxes lining the shelves. Lyndrea asked for a fruit skewer, which came in a dark blue jar, and the two sisters sat down at the table, Selena with a bowl of afzelii flakes and Lyndrea, eating a fruit skewer. The toast lay untouched.

Neptuna had left to go shopping for a package of fin grips, so Selena and Lyndrea sat alone.

"So... how many more months do you have to wait?"

asked Lyndrea, finishing off her skewers and getting up for another.

"The doctor's coming today to check on me, so hopefully, I'll be back on court in a few days... it's already been four months, and I haven't played a single Bubble... " Selena answered amidst groans.

"I don't know if I'm ever going to be able to play again... you know, with all my past injuries..." Her plaintive voice had visceral pain in it.

It was true. A Bubble Ball player's career can only thrive so much with injuries assaulting it over and over again. Selena had suffered from mental anxiety, broken fins, torn gills, internal bleeding and a twisted tail, all of which resulted in her having to stay at home many times. However, it was still a shock to her whenever the doctor said she had to stay home and 'rest'. How would resting help her to get better at Bubble Ball? Somewhere in the back of her mind, something nagged her, telling her that the doctor was right, but she still felt frustrated at the thought of staying home and doing nothing.

Lyndrea came back with two fruit skewers in her fins and gave one to Selena, who took it willingly.

"But don't you use this time to relax? You know, go to the shallows, watch movies, play board games?"

Selena sighed, "I do... but it gets boring after a while. I

Fish in Selena's town had about five main types of food, all prepared differently.

For breakfast, they had things like toast, anchovies, cereal and baked beans (which all came from the overseas market, imported from the waters around Urope and Ospreylia - the dangerous regions, since osprey, the fish's predators, lived there. Also, due to the fisher Humans, nets and ropes would snag your tail wherever you went).

For lunch they normally had soups and meat. The fish also ate krill, crabs and other small fish found in little rocks and anemone. Normally, they were put in tins and sent by the mailfish, but Selena's dad used to love going fishing and coming home with a bag of

mock-anchovies for dinner. Sometimes the fish ate whale blubber from whales found dead in the sea, and sometimes they had Hotonia salad prepared with ammannia sprouts, water lettuce and salvinia beans, seasoned with anemone for spice.

However, since the Gilliams were eating vegan, most of their diet had to be modified. Selena's favorite were krillburgers, but they were extremely unhealthy. That's why she normally ate them only when she wasn't playing a tournament.

One last thing. Food came packed in boxes made of cardboard, paper and other materials which weren't naturally water resistant but are coated with water-repelling gloss as well as WaterTyte, the top-selling brand of sealant. The fish also recycle many items of debris which floated down from the world above (though please stop your generosity in sending so much of your plastic our way. We are simple folk and do not use that much material for our needs! The excess is choking off our ecosystem.)

want to be back on the court and play!"

The doorbell rang. Selena quickly gulped down her fruit skewer and went to open the door. Lyndrea followed and smiled when she saw the doctor coming into the hall. Selena would be happy to get out of the house and onto the court for a change. If only the doctor would say her tail had healed!

Selena ushered the doctor in and they sat in the lounge.

"How's your tail now?" The doctor asked taking out a notebook. Selena wiggled it a little bit and said doubtfully, "It feels fine right now… but it was throbbing a bit this morning." The doctor, who was scribbling down notes as Selena talked, nodded.

"That's normal. It means your tail is healing, but it's not yet done. I think a few more weeks…?" Selena widened her eyes.

"A few more weeks!? Can't it be just a few more days?" The doctor shook his head.

"You can start mild training in a few days, but I would suggest waiting for some more time before playing a tournament."

He tore off the sheet he had been writing on from his notebook and gave it to her.

"I've written down a few exercises for your tail to help it

heal faster at the bottom of the page, as well as the number of reps you should do, and when. Also..." he pointed to the fruit skewer in Lyndrea's fin, "Eat things like those. Fruits, vegetables, bread... even soup is good. I would also recommend staying away from oily food, like fried krill and burgers." Selena nodded, though she guiltily glanced at the rubbish bin on the side, which was filled with mock-anchovy and krill-burger wrappers from Burger Kingfisher.

The exercise note looked quite simple:

Tail Exercises

- *Tail Twirls, both clockwise and anti-clockwise. 30 times each, every day. You can start anytime, but this is good for loosening up the muscles. If you do all the exercises, make sure to start with these!*

- *Two-finned push-ups. Most of your weight should be on your fins, and you can start easing onto your weak tail gradually. 20 to 30 times a day. Start this in a few days, when your tail is stronger and more consistent.*

- *Hold and Release. Hold big objects (not too heavy) tightly and then release. Hold for*

about 5 seconds and the release for 3. About 10 times a day. This is just as a warm up to make sure your fins do not get sore when you are unable to use your tail. You can start today.

- Flicks. Flick your tail back and forth and only propel yourself forward with your tail. No fins allowed. Swim a 5 foot stretch about 15 times every morning and night. Start in a few days.

Also, start eating more healthy food. I saw the burger wrappers in your dustbin... I would recommend staying away from those!

-Dr. Clamton

Lyndrea read the exercises over Selena's shoulder, and as Selena looked up to thank the doctor, she realized he had already left.

"Come on, Neptuna!! We've got to go practice!"

Selena was ready, fin grips wrapped, hair in a bun and a small bubble machine in fin. (Sales of bubbles in small

containers had been falling for years, and so the bubble manufacturers started making small bubble machines to adapt to changing times). Dr. Clamton had let Selena start training today, and she had woken up bright and early. Neptuna, used to such early-bird calls, was just swimming out of the kitchen, with two bottles of saltless-water and a granulated kelp granola bar. Selena had already eaten, and just as Neptuna was about to take the first bite, she was yanked out of the house by an excited Selena.

The girls had stopped practising in Bubble Ball academies. They now practised on courts with actual side spikes, near their house. Sometimes, they played with their dad, but mostly, they trained with a private coach. Today however, both sisters were free and decided to play each other.

And holy seahorses! Did they practice! They went after each other hammerheads and prongs, as fierce as they would in a normal match. They were both world-class players, and it was not a backwater pick-up game they brought to their practice sessions. Throughout the day, and hundreds of burst bubbles later, they called for detente. They hadn't stopped for anything but a quick bite of lunch, and an hour of rest as a break from the glaring afternoon sun. Now, in the cooling waters of dusk, they were thankful the day steeped in competitive spirit was melting away.

Selena returned home to a slightly throbbing tail, and she was worried that the practice had made her tail worse off. The doctor had said 'mild' training... but she was relieved

to hear the doctor telling her that that was because of how abruptly she had started to train. After so much time off court, her tail wasn't as accustomed to the intense activity.

"Just try not to swim too much. Don't practise so harshly. Go easy on your body, give yourself plenty of rest time, and ease back into the flow. Your tail hasn't healed completely yet." He had clarified on his MyFone.

Over the next two weeks, Selena gradually increased her playing time, stopping every hour or so for a break and playing only for a few hours a day. Her tail felt much better by the time they reached home everyday and she did the tail exercises prescribed diligently every night. In two months, her tail was completely healed, and her Bubble Ball ratcheted up to the old standards.

Selena was back in the game.

~*~

By late 2006, Selena had recovered her form and balance, breaking back into top 100 in the world and brimming with confidence. In the 2007 Ospreylian Open Sea, she went on to utterly decimate Maria Sharkapova to win the finals (the press called it *"arguably the most powerful display ever seen in femifish Bubble Ball")*, and even though she lost the "French Fry Open Sea" to ocean number one, Javelin Henin, she was full of optimism, energy and ambition for the future. She had returned to top-ten in rankings.

~*~

Tell-Tail Tales

Have I told you that when one of those days which remind you of your vulnerability arrives, it brings along its cousins and low friends as well?

It happened again in a match, and again against Danyella Anchovy, this time during the *"Wimbleswim"* tournament in 2007. A confident Selena had won the first set, and was getting ready to serve for the second one. Tossing the bubble high in the water, she surged up to deliver it over the net. As she touched back down to the ground, a very sharp shooting pain coursed through her tail and sent her sprawling over the sandy court. Her head throbbing with confusion and pain, Selena tried pushing herself up. Resistance from her tail made the effort futile.

The bubble had gone over the net, but nobody was looking at whether Danyella had hit it back over or not. They were gasping at what had happened to Selena. She was on the court floor in a debilitated state, twitching every few seconds. Her face was contorted in pain and as the intensity increased she started to moan. Her tail was hanging stiffly by her side and she carried it delicately in her fins.

It lasted for a few minutes and once the pain had subsided, she managed to get up gingerly and slowly swim to the sides with a wincing face. The medical attendant who had rushed over to help her quickly assessed and helped stretch her wispy tail. It had seemed like an intense cramp, so they thought it wasn't too serious.

Once Upon A Fishbowl

Feeling much better after the medical break, Selena went back on court to continue. She held her serve, which lead to a tiebreak. But just as they were about to start, the water started becoming choppier and suspiciously cyclonic. The umpire called a time-out: there was to be a delay due to rain.

After a three hour rest period, Selena won the match, with only faint traces of discomfort from before.

Getting up from the ground without your tail is a difficult task. Sometimes, exercise teachers ask their students to try by tying up their tails and using only their delicate fins to push upwards. The point of the exercise is to improve upper body strength and the muscles inside your fins. I think the human version of that is called a "crunch".

Tell-Tail Tales

In the next round - the quarterfinals - a couple of days later against Javelin Henin, Selena collapsed again. It was yet again on court, but this time, she didn't get up. Through blurred eyes, she could see fish swarming around her, murmuring and trying to call for help. Not again. Over the din of the crowd, she could faintly hear some fish calling out, "Selena! Selena!". It sounded like Neptuna, but Selena couldn't be sure. As she watched, the fish-crowd around her parted and Selena saw a light orange another fish approaching with a fish-aid kit in his fins. *Not again!* Selena felt herself being lifted on a stretcher and gazed around wildly.

"What happened? I need to play! Ow…"

No one answered her until she was on the bench. Her vision had cleared and she saw that the light orange fish was checking her heartbeat. He ran a few tests on her tail and then said slowly, "I think, Ms. Gilliams, that you've got *quadriceps tailins*… it's normal for sports players, but unfortunately you're going to have to take a break from Bubble Ball for a few months..."

Selena shot upright in a shock, but hurried back down again when she felt the shooting pain.

She shook her head agitatedly, grasping for something, anything, that would have convinced the doctor to change his mind.

"Health comes first, Selena. The sooner you get better,

the sooner you can play Bubble Ball again." He said, packing up his reefcase.

Selena was downcast, felled by injury once again. She went on to finish the match as a true warrior fish, eventually losing to Javelin 6-4 3-6 6-3.

~*~

She would have to re-group. Re-train her body, and more importantly, re-train her spirit.

There can be grace in fall, and there is further grace in the subsequent rise. The rollercoasters in life do not relent, but how you respond to and even enjoy its vagaries and challenges determines the fullness of feeling with which you leave the world.

Tell-Tail Tales

Ten
Yes We Can!

"We did not come to fear the future. We came to shape it."

~ *Barack Obama*

couple of years later, not too far removed from Selena's unfolding sterling career, was an event almost entirely different, but curiously alike. It was about 7:00 in the morning, and many were still drowsily turning around in their beds. Light washed itself down a water-lane, rounding the corners and clinging to the shingled roofs. There were two fish warming up to the day and acknowledging each other - Miss. Ray Fintops and Mr. Tosanoides Obama. Obama was an early riser, normally awakened at 6 AM by a tinkling alarm. Presently, he had about half an hour to spare before heading to the *Blue Lake Shoemake Elementary*

Once Upon A Fishbowl

School, where he was going to cast a vote.

Obama was not just a fish in the crowd casting a ballot. He was one of the fish swimming for the exalted post of *The Most Powerful Fish In The Ocean*. At the end of the day, he could very well be the next President of the United Shoals of Americlam.

So, papers and pens in briefcase, family jittery with pride and excitement, Tosanoides Obama, along with his wife, Etheostoma and his two children sat in a fancy limoray and drove to the School (Later, ever the clownfish, Obama said:

"I noticed that Etheostoma took a long time to vote. I had to check to see whom she was voting for!")

Obama, a Democrab, was going up against George Swish, a Repelican, in the presidential elections, and the fact that a blue fish had a chance to win an election against a yellow fish had just strengthened the hopes of the blue community. Things were finally moving, changing in the favour of the oppressed. The once unthinkable was occurring. A BLUE fish from humble backgrounds had a shot at becoming one of the most prominent leaders of the free ocean. From modest beginnings as an errant student and then a conscientious organizer of local fish, Obama had swum up the political ladder, from the local Fillinoy Senate, to the United Shoals of Americlam Senate to now a presidential candidate. The Shoal had come a long way

Yes We Can!

from the Emancipation Proclamation...

~*~

History had its say. Obama won. He won by a *massive* landslide, obliterating the barriers, at least temporarily, erected by the color of the fins and inspiring the entire Shoals with a message of hope and change.

Obama had proclaimed: *"YES We Can!"*. Yes, they had.

The blue fish had finally broken through a ceiling once considered impossibly high and unreachable. Perhaps, through the next four years of Obama's presidency, a stronger bridge between the Yellow and the Blue fish could be built and nurtured. Perhaps the fishism, so prominently displayed through the denial of services, clicking locks of a door when a blue fish passed by, disproportionate prison sentences for blue criminals relative to yellow ones, and so many other ways, would become fading memories. Perhaps they could be replaced and substituted with equality and kindness.

Obama held in his fins a power that no Americlam Blue fish had ever touched. It marked the spark of a fire, burning on through the repelling waves of water. It was an immediate call to all the blue fish - no, all fish. It was a call to answer to their immediate *calling* , work toward an egalitarian society, living in sympathy with the ecology and environment around us.

Once Upon A Fishbowl

His wife, Etheostoma, was not the kind of fish to stay at home and bask in reflected glory. She was a very accomplished femfish in her own right even before her husband had become famous in politics. In her new role of First Fish, she used her position to inspire women and promote healthier life choices. She launched the "Let's Swim!" and "School Lunch" initiatives with community leaders and professionals from various fields of education, medicine and nutrition in a shoalwide effort to address obesity amongst the frys. She started the "Reach Higher" program to help fishlings all over the US complete their education past high school. Particularly passionate about inculcating a sense of self-confidence and determination amongst young girls, she initiated the "Let Girls Learn" program to help girls around the world get a decent education, encouraging them to break ice ceilings and kelp entanglements. Her main message was:

"You don't need mammon or connections to influential people to succeed if you don't let your fear stop you."

She sponsored the US Bubble Ball Association to build or refurbish thousands of fry-sized Bubble Ball courts across the shoal, training coaches and signing up hundreds of thousands of fishlings to promote well-being and fitness through the sport.

Yes We Can!

From the Obama family, ideas, views, speeches and tangible actions spread like an ocean hurricane.

YES. They *Can.*

YES. They *Did.*

YES. They *Will.*

A landonaut is a fish that travels up on land. I myself have an acquaintance with one of them, which is how I know so much about you and how your hair always stays flat. Curious. Our hair waves about. Anyways, landonauts are able to do this by being deliberately 'captured' by humans and placed into a fish tank. A true landonaut gathers intelligence on the land above and then escapes at an opportune moment to return to the sea. Do you remember Gill from Finding Nemo? He was a landonaut, a most worthy and famous one down in the seas.

Being a landonaut is a hazardous business, with a low success rate of return. Many die because of the vacuum. Many die at the hands of humans called "Chefs". Many stay trapped in the fish tanks for

Yes We Can!

*life. But many brave fish still aspire to be landonauts
for the knowledge they can bring to us.*

𝕰𝖑𝖊𝖛𝖊𝖓
High Noon at Indian Shells

"Nothing is impossible; the word itself says "I'm Possible"."

~ *Audrey Hepburn*

𝕷et's rewind yet again, for I seem to have vaulted over many Mariana Trenches in my effusive seal...umm... zeal. We must head back to another landmark incident in Selena's life, one which seared her intensely.

~*~

The day had arrived. Semi-finals at the Indian Shells tournament in 2001. Both the Gilliams sisters had overcome strong opponents to reach the final-four stage, and now their grouping had brought them face to face. Two sisters, one

match. Only one could proceed to the finals. It wasn't the first time they were playing a match together, and both the fish knew they were ready. But the day felt different. The ocean water seemed distant to them. A bubble of anticipation coated their body, drowning them in contemplation and anxious thoughts.

The two fish made their way to the changing room, oblivious to everything but their game to come, and they stretched their fins, mentally preparing themselves in silence. Sisters or not, when the time comes to play a match, your opponent does not know your strategy, and vice versa. Neither knows the shots one would be willing to play, or the level of aggression one would be willing to show. Staying focused was imperative before a match. And so, at first, Selena hadn't turned her head when she heard the small cry of pain from Neptuna's mouth. It was only after Neptuna gasped out a *"Selena! Selena, I can't move! Ow!"* that Selena, confused, turned around. Her sister, hunched on top of a bench, was doubled over, her tail in her fins, and she was stiffly trying to talk.

"It hurts!" she moaned. "I...I... I don't think I can... play..." Neptuna said, trying to swim over to Selena's bench.

Selena rushed to help her, calling out quickly for an attendant. The hallway outside was a flurry of activity, from camera crew setting up lenses to attendants checking on schedule, so it took a while to find the right fish. When the nurse shark finally arrived, she quickly assessed Neptuna's

Yes, not all sharks eat us. It is a myth in the human world that all sharks are dangerous. Not true. Some are more dangerous than barracudas, but there are others which are very motherly and caring. One species, not yet known to humans is the "Nightingale Shark", closely related to the species humans do know, the "Nurse Shark". Nightingales only eat seagrass and coralline algae, and have excellent sense for fish physiology, making for very good medical practitioners. One of the most well-known Nightingales was a shark called "Florence", who started the practice of nursing and tending to the injured during a particularly vicious fish-war.

tail, hastily scribbling notes on a lined yellow mosspad. Bending Neptuna's tail slightly to the left caused a cry of pain from Neptuna, and doing so on the right wasn't any better. The nurse frowned, gingerly propping up Neptuna's tail on a soft mollusc-chair and covering it with a grey antiseptic towel.

She sighed and said, "You had filed in a comment about this before, as I recall correctly... It looks like tailinitis. I mean, we can't know for sure until the doctor arrives, and we'll probably have to show you to an X-ray fish... I think it would be foolish to play now and put your tail in danger..."

Neptuna widened her eyes.

"You're normally meant to give a thirty-minute warning! " she moaned.

There was regret in her voice. A few hours ago, she had informed the tournament officials that she might have to pull out of the match because of the injury she had sustained during her quarter-final match against Demoiselletieva. As it happened, the officials decided to wait and see how she recovered by match time, and Neptuna was also reluctant to back out of a marquee match against her favorite, and beloved, opponent. Now she wished she had decided to pull the plug earlier. This was not going to sit well with the crowd. Injuries are common amongst players, but not injuries announced five minutes before a match, without much warning.

High Noon at Indian Shells

Their parents were waiting expectantly in the stands when a hassled attendant went over to tell them what had happened. They looked mildly surprised and followed the young fish into the room where Neptuna was still moaning. She was able to move her tail more easily now but it had a twisted look to it, as if it was being held at an angle. It was clear that Neptuna would not be able to play that day. Time was ticking, and the last stragglers in the stands were getting to their seats, anticipating a fierce battle. Fishard sucked in his breath and finally shook his head.

"She can't play...", he said with resignation.

It was final after that. There was no use arguing, and no one did, because while Mr. Gilliams was their most reliable coach, he was their father first. And if he thought that that was what was right for his daughters, then that was what was right for his daughters.

No one was happy with Neptuna's withdrawal, especially four minutes away from the semi-finals. Many had expected Neptuna to at least try playing, and a rumor started flitting from mouth to mouth that Fishard Gilliams had staged the whole episode in order to bring Selena higher up. The waters were heavy with disappointment, and disappointment sometimes breeds uncharitable comments.

Selena, who had advanced on to the finals, was scheduled to play against a fish named Fin Clijster, who was one rank higher than Selena. The water was tense, the crowd on the edge of their seats. It was a particularly nice day, the

clouds slightly casting distorted shadows in the water, and the filtered sunlight weaving through the crowd. Even in the changing room, though, Selena could hear a faint buzzing from the crowd, and a sense of dread filled her. Fin Clijster, who was floating across from her, on the far end, was deep in thought. She was an orange fish with light crystal skin and a toothy smile, but today her forehead was furrowed in concentration. An attendant hurried in.

"Your match will be starting shortly." Selena rummaged in her bag and found a pink headband. It would have matched perfectly with her pink and green outfit, but she decided not to wear it. Her head was starting to hurt with all the ruckus the crowd was making. Quickly adjusting her dark blue fin grips, she clipped on a necklace. It had a heart pendant on it and was a shining silver color. The attendant kept glancing back outside nervously and then cast a sympathetic look over to Selena. In a bubbling mass of confusion, nerves and excitement, Selena swam out of the changing room and into the waiting area. The umpire's voice was muffled by the sound from the crowd, but Selena could just make out a cheer at the end of the word 'Clijster!'. Fin swam out, boldly, but clearly nervous. The crowd erupted into cheers, clapping and thumping on the stands with their tails. The umpire then boomed out, "Opponent: Selena Gilliams!"

As Selena emerged from the waiting area, she gazed out at the flashing lights and swishing tails in the stands. She was accustomed to this feeling, but it seemed unnatural. Something was wrong. She studied the crowd, trying to

spot her friends and family. She finally noticed her dad and Neptuna who were making their way down to their section in the stands. Suddenly, the two of them stopped swimming. Squinting, Selena saw her father and sister shaking their heads, and there was clearly some commotion. Her father raised up a fin and shook it angrily in the pristine water, and Neptuna tried to hurry down. It was then that Selena heard what was happening. Contrary to the cheers that steered Fin into the match, boos and jeers were being hurled at Selena. All she could hear was noise, and it throbbed against her head. This wasn't the usual Indian Shells crowd that she was used to hearing. Normally, the crowds would come for a lively match, and cheer every good point made, regardless of who won it. Normally, the crowd would clap for the underseal as well as the champion. Normally, the crowd would shout out positive support for both players, urging the match on. But it appeared that the day wasn't meant for "normally".

Meanwhile, in the stands, Neptuna and Fishard Gilliams continued their trek down to the stands. Neptuna vaguely heard her father responding to a particularly nasty comment, one that referred to both blue fish's fin color, and she widened her eyes in surprise. This had happened before, but certainly not from this crowd. Agitated, she tried to swim down faster to where the rest of her family was waiting, in the shaded, front-row stands. Neptuna looked at the top-water, her frown deepening. Even though the weather was nice, it felt like an army of clouds was lurking just over the horizon. She got worried. Rain meant tiny shards and ripples, and it was an unsafe condition for all players. The court would get

slippery in the rains because the impact of the waves would wash out the water-resistant gloss that covered it (The gloss made the court softer and if one of the players wanted to let the bubble bounce before hitting it, it would let the bubble bounce without popping. It also ensured that fish did not get that hurt when they fell down.) And to top it off, the crowd was unnaturally hostile...

The warm-up began, and Fin and Selena rallied a few bubbles before practicing their serves. The crowd was getting more tense, and had started to boo more loudly. Selena, trying to block their sound out, hit the bubble back with more intensity than she meant to and it popped quickly on her fin, spraying her with cooling mist. The crowd cheered at her miss hit, even though it was only a warm up. The umpire called out for the crowd to be quiet and then took the toss. Selena, choosing fins, lost, and Fin served first. Selena easily won that first point. The crowd boo-ed again. Selena winning the first point had immediately triggered a negative reaction. Shaking off her nerves, she swam to the left fin side of the court. This was the match that her father had always trained her for.

"Focus on the bubble. Not the crowd. Whatever the crowd does, whatever your opponent does, focus on that bubble. The crowd can do anything. They will scream. Shout. Boo. Cheer. But all you care about is hitting that bubble back in the court."

High Noon at Indian Shells

But despite knowing this, Selena felt red anger bloom over her cheeks. Brewing down in her stomach was a monster, one that was biding it's time to roar out. Her head swimming, Selena drowned out the voices showering down on her, and stared at the translucent orb glittering in front of her. The serve was powerful, and as Selena swam to intercept the bubble, she could feel the vibration in the waves. The voices dimmed and all she could hear was the swish of her fin hitting the bubble over the net. Fin hit a shot down the line and far from Selena, which meant Selena had to dive for the bubble. It dropped straight over the net, bounced against the courts and then Fin came hurtling over and smashed it cross court. It was a fast, spinning bubble, and even Selena couldn't get it. The crowd cheered and clapped, even though it was only one point. 15 all. The match had just begun.

~*~

Selena could taste the anger in her mouth, fizzing out in bursts of well played shots. The boos and jeers from the crowd had caused Selena's fury, but she was more motivated than ever. The crowd was cheering every double fault of hers, every error she made and every shot she missed... She felt waves of collective oppression coursing through the stadium.

The score was 3-3 in the 2nd round. Fin had won the first round and now they were neck to neck. The crowd was excited; surely Fin would win now! But they stated their shock in angry boos and mocking taunts when Selena won

two more games. The score was 5-3, in games, and Selena now had a chance to beat Fin. Selena served a bubble, and Fin hit it to her backfin. The rallies were long and difficult, and Selena longed for just one gulp of an ice cold drink. She was losing the game love-30. Exhaling sharply on her next serve, Selena aced Fin. 15-30. The game continued. 15-40. 30-40. Game. Selena kicked the court in frustration.

5-4. One of the ballfishes gave her her towel and she wiped the sweat that was seeping through her skin. Lightly sip-gulping the filtered water in her bottle (fishes never drank water straight from the sea. It was extremely unhygienic and dirty), Selena took even breaths. They seemed ragged and heavy, but it was the only thing she could hear. She had drowned out the negative voices games ago, but they still powered her on.

The umpire called them back on the court, and she could vaguely hear her father belting out cheers for her. She smiled lightly. It never happened that her father didn't encourage her, and she appreciated his ceaseless care, especially during a tough match. Selena looked over at the stands one more time. Her mother was focused on the match, looking disturbed by the commotion, but nevertheless clapping. Fin caught a bubble from the machine and then served it. The points kept pinging back and forth. 15-love. 15 all. 15-30. 30 all. 30-40. 40 all. It was deuce. Selena got the advantage point by faking a lob and actually hitting a drop shot. The next point was vital for Selena; she had to win it.

High Noon at Indian Shells

Wiping away a bead of sweat, Selena readied herself for the serve. Her fin grips were starting to get loose. Fin faulted. Then her bubble hit the net and just made it over. Selena sighed. Her grips were slipping by the second! When a bubble touches the net and then goes over, you have to re-do the serve. Fin served and Selena hit it back with a forefin. The bubble wobbled a little, and hit the net. Deuce again. Selena saved a match point after Fin aced her and got advantage, but she could see that her fin grip was unravelling, the sticky part washed away. Selena got the advantage point because Fin double faulted, but the next rally was a hard one. Fin, noticing the grips, kept hitting to Selena's forefin, until Selena was able to return the bubble just on the baseline. Fin didn't expect this, and she hit a defensive shot to Selena's backfin, and Selena, exhaling sharply, swiped the bubble slightly to the left. It bounced once on the shiny court and then popped on the side spikes. Selena had yet again won the game!

Back in the stands, Neptuna fiddled around nervously. She was angry at the crowd, but also worried for her sister. She could see her re-wrapping her fins in the same color as before; dark blue. After that, Neptuna saw Selena looking up at the crowd for a fraction of a second, her eyes sparkling with determination and anger. She wasn't confused anymore. She was ready for the next round. And Neptuna knew, right then and there, that her sister had won. They hadn't even started the third round, but Selena had already won the match. And so she did. Wrapping up the match with a clean, 6-2, Selena was crowned victor of the tournament. The crowd was filled with grudging cheers

and claps, all dripping with disappointment. Selena almost couldn't breathe. She had won one of the hardest matches of her life and she had proved to the world that she could win against a crowd that thought she couldn't. She shook fins with Clijster, and then, tired but refreshed after the win, she waved to the crowd. Her breaths were excited and short and she ran to her parents and sisters, who received her with huge smiles and hugs. Then she hurried back to the court to receive her trophy. The umpire was calling out, trying to be heard over the crowd,

"2001 Indian Shells tournament winner, Miss. Selena Gilliams!"

Selena waved at the crowd, despite them booing her down, and when the ceremony came, she accepted her trophy with a great sense of pride.

As she stared back at the burning eyes in front of her, she smiled and stared back defiantly. Because she had won the match, and not one of the thousand fish in the crowd had been able to stop her.

High Noon at Indian Shells

Twelve
Love and Forgive Freely

"Some people wish it would happen, some people want it to happen and some people MAKE it happen."

~ *Michael Jordan*

hat had happened at Indian Shells was extremely unseemly and unfortunate. The crowd was voicing its displeasure at what it felt was a rigged setting, but set against the stark contrast of a predominantly yellow-fish crowd hurling racial insults at blue fish, there was no mistaking the memories of the country's fishist past. Perhaps the crowd was not really being fishist, but issues of fin color and discrimination are always sensitive and can trigger unintended inferences and conclusions. Perceptions take on

a very different dimension when colored by past experience. The crescendo of anger directed at the Gilliams' that day was a jarring reminder to those in the blue-fish community that despite giant strides made by the divided society, the undercurrents of discrimination based on fish-color remained right below the surface in their shoal. It raked raw thoughts and painful memories which had never really been healed. As Fishard wrote years later in his book,

"The chorus of boos that cascaded through the stadium sent a powerful message to Americlam, to Neptuna, to Selena, and to me. It was a message from the past, one Americlam tries to put behind it but can never forget. It was a snapshot from the days when the open humiliation of the blue race was accepted without question."

(source: Richard Williams, "Black and White: The Way I See It")

Would the crowd reaction have been mooted or non-existent if these were yellow-fish sisters playing? Would it have made a difference if Neptuna had revealed her injury earlier instead of at the last moment?

We will never know, though opinions abound. What did happen was that the Gilliams did not appreciate this treatment by the fans at Indian Shells. It stung like an electric eel. Growing up in a society which continued to simmer and stew in fishism had conditioned them to be sensitive to such

Love and Forgive Freely

public behavior which could be attributed to discrimination and racial bias. Perhaps the crowd did not intend it, but in such matters, a few dirty fish muddy a whole pool of water.

After that bittersweet experience, both the sisters decided to boycott the entire event in the years to come. It was a matter of self-respect for them, and mammon and accolades could not erase their sour experience, especially as meted out to their father. For both the sisters, integrity was to be valued above everything, as their father had taught them. The allegations of match-fixing cut them deeply. As Selena recalled in her article in the *"Climes"* magazine in 2015, she suddenly felt unwelcome, alone and afraid in a game she loved with all her heart. When she was booed by what seemed like the entire ocean, her voices of doubt became insistently real. It haunted her for years, this fact that her incredible father who had dedicated his life to prepare his daughters to overcome all racial and gender-based obstacles had to sit there and watch his daughter being taunted mercilessly. It rekindled his very unkind memories of childhood growing up in the Southern parts of USA. In tears, she wrote,

"It has been difficult for me to forget spending hours crying in the Indian Shells locker room after winning in 2001, driving back home feeling as if I had lost the biggest game ever—not a mere Bubble Ball game but a bigger fight for equality."

~*~

179

Once Upon A Fishbowl

The boycott by the sisters lasted many cycles.

Fourteen complete years. For fourteen years, the Williams sisters stayed away from Indian Shells.

Many thought this was excessive. There were journalists and reporters who raged that the sisters were being petty; feeling entitled; being unreasonable. However, for the sisters, the boycott was a symbol of taking a stand; a stand against the social bias against blue fish. A handful of racist remarks, and a biased crowd was a glimpse into the underlying oppression many blue fish continued to face on a daily basis in the USA, and this was unacceptable so late in the twentieth century. Years of steadfast will from the sisters was their backlash against the system. Blue fish do not just sit back. They do not just accept the insults and criticism. They stand high, chin raised and chest out, and deflect the negativity driven towards them. Theirs was an insistence that status quo was not to be accepted in silence.

~*~

After fourteen years, Selena finally forgave the crowd, the event and the organizers. It had taken a long time for her to heart to heal, but she had never forgotten her mother's teaching - *love and forgive freely.*

With peace in her mind, Selena competed again in the 2015 Indian Shells competition.

Ironically, history almost repeated itself. Having reached

semifinals, Selena had to withdraw from an injury to her right tail-fin…

This time, though, the crowd gave her a tearful farewell. Their Amazonian warrior had returned, even if the she had to withdraw from the battle for the moment.

In 2016, a year after Selena's return, Neptuna decided to return to the event. She described it as a difficult process, but said that the courage of her sister had deeply inspired her to follow suit, to return back to the place where the crowd had failed her and her family so long ago. In her letter to the officials and posted on the ocean-wide Hydronet, Neptuna concisely expressed her disappointment and frustration at the crowd. Hadn't the oceans drifted past those times of bigotry? Didn't all fish deserve equal rights in this sea of opportunity, where dreams were meant to come true, where any fish could be anything? Wasn't it written in the Declaration of Fishium Rights, and wasn't it acknowledged numerous times?

Was this the behavior for which Americlam wished to be known?

The question remains hanging in the coral reef.

Thirteen
Standing Tall

"I don't want other people to decide what I am. I want to decide that for myself."

~ *Emma Watson*

This book has come to a close, as I am sure you have gathered. My notebook is bursting with words, in danger of becoming an overstuffed walrus so I must give it a rest. I could keep expanding on Selena's incredibly successful life … but I think that if I've intrigued you and gotten you interested enough, you could perhaps learn more about her on your own at the local library or on your own Internet (Yes, Selena's story has crossed over from the Hydronet and is now in public human domain).

She has had her share of storied rivalries; she has had

her patches of down-swings and failures, but she has also made many friends and expanded her family. Selena still pursues the game of bubble ball game. As I write this, she might be halfway across the ocean, hitting winners at her arch-rival, Sharkapova, or in her hometown of Beaverly Heels, Dolphornia volleying alongside her talented sister. She continues her practice matches with Caroline WozniMacki when Neptuna is busy, and gathers lunch with Roguish Rederer when they're both in town. She visits Isha and Lyndrea often, and they rewatch all their favorite shows. She writes history for the future, stories of hard work and steel determination springing off her fins as she slices the bubbles. Sitting at the top of the world, she has the luxury of surveying all which has passed and all she has achieved - Olympic medals, dozens of singles, doubles and mixed doubles titles (including many jointly with Neptuna), "Career Slams", "Selena Slams", tens of millions of sand-dollar earnings, etc. etc. etc. It is a dizzying experience to recount and relive her fabulous career path.

She is a fish with the claim to being a GOAT.

Greatest Of All Time.

What more could a simple fish want?

~*~

While this book may be in it's last pages, it still breathes reflected reality. We may have overcome some forms of slavery. We may have overcome a million milestones of

shortcomings and fish-failings. Yet, we are still slaves to our own mistakes, repeating them as a constant history. The faces may have changed, and the times, but we are still insistent on rising through the defeats of others. As mere fry, we exclude and intimidate our fellow pupils, and grow up as close minded and intolerant fish. We are careless with our words and actions, not realising that they stay lodged with the fish at whom we aim the barbs.

We have a short time on this planet, and we never know when we will have to depart. Is it too much to ask to make it enjoyable and worthwhile? Is it too much to ask to preserve it for the upcoming generations? We are all born equal. Different, perhaps, but equal all the same. Let us embrace that with all the love of fishianity.

Here's the moving response of the human tennis player, Serena Jameka Williams, when confronted by a racist comment from another tennis player of yesteryears:

"I have said it once and I'll say it again: this world has come so far, yet we have so much further to go. Yes, we have broken down so many barriers, but there are a plethora more to go. This or anything else will not stop me from pouring love, light and positivity into everything that I do. I will continue to take a lead and stand up for what is right."

Fourteen
The Circle of Vice

"The world doesn't belong to leaders, the world belongs to humanity."

~ Dalai Lama

INIQUITIES ~ VIGNETTE 4

She sits, fins folded in her lap, tail tucked beneath the metal chair she is sitting on. The classroom is filled with banter, clouding up the room, but all she hears are spiteful words floating in the silence that blares through her ears.

"Needs more makeup…"

"Too thin…"

187

Once Upon A Fishbowl

"Too fat…"

"Nofish likes her… how does she even *live*?"

"What a nerd!"

Her unpolished yellow fins brush against the side of her desk, another reminder that she falls short of the beauty standards required to be considered 'normal'.

"Her skirt is too long…"

"Eww…"

"I hate her."

"She's so ugly. What a *shark!*"

"She should just kill herself…"

Her eyes squint, wandering over the room to where cluster of girls perch happily in a circle. To their right, boys wade around, and they bask in comfortable confidence. They only have a few minutes for class to end. She can bear it. She can bear it.

Can she bear it?

~*~

INIQUITIES ~ VIGNETTE 5

He ducks into the dim passage, clutching a worn package in his hand. It's a book for his daughter, and he has to rush to make it in time before the shops closed. A stone whizzes by him, and he sighs. Ever since a shoal of fish had seen him swimming out of the mosque and the new president had released a statement against his type, he has been harassed by a persistent gang of Musselimophobes.

He quickens, smelling the drunken hate from wades away.

Another stone brushes past him, and a fin gropes around, latching onto his tail. It pulls, and he winces.

"Terrorist."

It's a word he's heard before, and he looks into to the dark eyes, suddenly scared.

His package flies to the ground, battered. No one hears him while as he is pummelled over and over, hurt again and again and again. His body slumps, unconscious, as the gang leaves.

The police find him. He is revived. The gang remains unidentified and rich.

~*~

INIQUITIES ~ VIGNETTE 6

Somewhere, a girl is sitting. She is fixated on the screen in front of her, currently the only source of light in her room. Her desk is a jumble of thoughts, ideas and scrunched up opportunity. A glassy tear is finding its way down her face.

Hours away, a group of fish huddle around a phone screen, laughing uncertainty. They've finally done it. How will she react? What will she say? Will it be as dorky as they imagine? They keep staring at the conversation they've just had with her, engraved into the digital world of texting.

Sara: ur such an idiot, u know that bree?

Bree: what did i do? why are u being like this?

Sara: u really think we wanted to be your friend?

Bree: ??

Sara: u still don't get it do u? ur annoying and clingy and WEIRD bree! Always bragging about ur stupid drawings and trying to tag along. no fish likes u.

Bree: what?

Bree: y?

Sara: srsly. just do us all a favor and kill urself.

Bree: …

The Circle of Vice

Bree logs off. Sits in the dark for a while, tail folded underneath the chair, fins furiously wiping away tears from her face. She doesn't know what she's doing when she swims downstairs. She doesn't know what she's doing when her mother asks if she's all right and she nods, laughing slightly.

Of course she's all right. Why wouldn't she be all right?

She doesn't know what she's doing when she goes to the bathroom. She doesn't know what she's doing when she locks it, sits on the edge of the tub, and kicks her tail repeatedly against the marbled walls. She doesn't know what she's doing when she cries into the mirror, and screams into a muffled towel.

She knows what she's doing when she scrambles to open the medicine cabinet. When she takes out five bottles of tablets. She knows what she's doing when she decides to swallow every single one.

Hours away, a group of fish wait eagerly for her response. They never get it.

ℭifteen
Deja Vu

"Life without love is no life at all..."

~ Leonardo Da Vinci

ℭhe beach is in the same state that we left it in; tranquil and placid. Nothing seems awry, and the sunbathers on the beach are content.

Our ship is back to life. All hands on deck, as they say. The wet sailor huddles with a mug of warm chocolate. A towel of sun drapes around him and he cheers with merriment and bliss. A few fishermen who know how to fish launch their lines across the water, flicking through the watercolor sky. They want to see who can catch the biggest fish.

A solitary cloud capers over the boat as one of the men

pulls up his rod. A squeezed plastic bottle with a peeling wrapper drops to their feet. As if in a trance, the men pick up the bottle, grimacing at the muddy insides and crushed form. It reminds them, if only briefly, that the beast they ride upon clenches their overflow of refuse and garbage in furious hands.

The sea can sense their understanding as they stow the bottle away instead of tossing it back into the water. The cloud passes. Sunbeams tether the hull in hope - maybe things can change. The water glides, the sky stretches its arms further and the sand sifts.

Calm. Serene.

Calm.

Serene.

Deja Vu

Epilogue
Destiny in a Bottle

"Fantasy is a necessary ingredient to living. It's a way of looking at life through the wrong end of the telescope."

~ *Dr. Seuss*

The sky was aquamarine, radiating back the warmth of a late-afternoon sun. The sand spread out far in the distance, its softness tingling and caressing her bare feet as she strolled across, lost in her reverie. Her dark hair brushed against the nape of her neck. The gentle breeze lulled her into waking dreams. All the years of pain and anguish and heartbreaks of failure had fallen behind. Her mind had found its equilibrium. There was peace even in the occasional losses; they were minor milestones, just as

her successes, in the long journey of her spirit. As she gazed at the waves rolling across the sea and spreading themselves with joy on the shore, it struck her that the sea had discovered this secret long ago. It brought a smile to her face.

She thought of her one-year old daughter, *Olympia,* who was her innermost joy, her own essence. Olympia's presence had given her a new perspective, a new sense of calm. There was more to life than games, than competition, than everything the universe had to offer. She wondered if Olympia would grow up wiser than her, ahead of her age, in a world whose playing fields perhaps were a bit more level...

Time would tell... and there was time enough for the future.

A glass bottle caught her eye. It gleamed a spectrum of green rainbows, the sand making a perfect ovate dent in the yellow grains around it. How long had it lain there waiting, one does not know. They say every bottle in the sand is a talisman waiting to foretell the destiny of its finder.

That, of course, is just an old mermaid's tale.

Serena picked it up, sensing a beautiful secret. The cork on the bottle strained to release itself. Serena helped it with a soft pull. With a subtle pop, the cork released its guardianship. Wisps of sea-scent wafted out, fresh with the metallic taste of mystery. Dried parchment of seaweed unfurled, with what looked like hieroglyphs marked on it. Serena pried open the corner of the first page from the bundle and unfurled it.

Destiny in a Bottle

Many of the writing marks had bled into small, oily drops.

As her eyes adjusted, she started reading. Her lips parted, a whisper escaping her mouth, stretching drowsily into audible sound:

"The fourth window in the Gilliams household was illuminated with light. Shadows sheathed the brick walls, silhouetting three distinct fish..."

Fintastic Quick Guide Series

Bubble Ball
Basics For Fish Fry

~ by Clea Greylake

Once Upon A Fishbowl

Are you trying to be the next big thing in Bubble Ball? Swim easy. In a few simple lessons in this Quick Guide, you will be on your way to an Ocean Chomp-ion-Ship! Here are a few Bubble Ball vocabulary words, and some bonus tips and tricks, that you should know!

A Bubble Ball beginner must learn three things: The court on which the game is played along with the equipment, the rules of the game, and the basic shots and strategies involved in a winning play. Once these are under your gills, breezing through the games will be a fry's play!

Different Strokes For Different Folks!

Bubble Ball is a game played with your fins and a bubble. Simply put, you need nothing more than yourself and a small encashment of oxygenated water! It's as easy as that!

- **Backfin:** This is the one of the two most powerful stroke for most fish as you use two fins to hit this shot. Some players can hit with only one fin, but small fishes always start off with two fins. To hit this stroke, you intercept the bubble with your left fin (all fishes are right finned) and close over it with your right so you are holding the bubble. Don't hold it to tightly or it'll pop! After you receive it, swing it back over the net. This should happen very fast so that the bubble doesn't burst on your fins. Typically, it is best to curve your lower fin over so it doesn't spin too high. This is called brush!

Bubble Ball Basics for Fish Fry

- **Forefin:** This is the most powerful stroke in Bubble Ball, executed with your dominant fin. You must simply hit back the bubble when it comes towards you. Make sure you don't flick your fin too hard or whip the bubble sharply. Hold your fin at a downwards 45 degree angle and push upwards, which will give the bubble a nice smooth passage over the net.

- **Volley:** This is something you do when you are near the net. This can be done defensively or whilst attacking. Simply let the bubble bounce lightly on your fin and let it float to the other side. Do not swing your fin like you normally would whilst playing, but just block the bubble. This is played more in a doubles match, where one fish is standing up by the net to volley. Note - a volley is NOT the same as a smash!

- **Smash:** Smashes are typically used when a player is at the net, but can be done from the baseline. If the bubble comes high over to you, you can forcefully bring it down over the net, like a serve. This is one of the hardest to master (in the basics) and arguably the most effective in finishing off the point! To hit a smash, bring your right fin in an arc over your head so the bubble is guided down to the other players court. Fishes tend to think that to smash you must whack the bubble as powerfully as you can; this is wrong. If you bring it down fast and steady with a the correct snap technique (see The Best Smashes by Puffer L. Fish), the power will be more than enough.

Once Upon A Fishbowl

Remember, it's your attitude that counts! Everyone's a winner.

These are the basic strokes, but you can learn more about them in the next manual called A Guide to Bubble Ball Perfection written by Vicky A. Lochness. You can also read Stroke by Stroke - Your Bubble Ball Coach, written by Martina Doris Clearwater in the 1980's.

The next section will introduce you to the Bubble Ball court and terms used whilst playing.

The Keys to the Court!

- **Baseline:** This is a word you will hear quite often, and it refers to the very back of the court. It is the line that most players will hover over while waiting for or getting ready to hit a serve. If a bubble goes out of the baseline, the bubble is called OUT! It's a good strategy to hit deep, baseline shots so your opponent won't get a chance to strike, but you should vary your shots so that the other player doesn't know what to expect.

- **Service Box:** The service boxes, which makes up half the court are the two boxes in which the bubble must land to make the serve legal. Serves must be cross-court. If the bubble pops before going over the net, doesn't land in the box or pops in the net, you get one more chance. However, if you do not make the second serve, your opponent receives the point.

Bubble Ball Basics for Fish Fry

If your serve touches the net but lands legally in the service box, then you have a re-serve, where you must redo that serve.

- **Sidelines or Side Spikes:** These lines are on the side of the court. If the bubble bounces outside of this, the bubble is out. On most courts, side spikes are used, however some use the lines instead. The spikes are placed just outside of the court so if a bubble bounces on a spike it is automatically called out!

- **Mid-court:** Mid-court is used as a term for the middle of the court, where most Bubble Ball players stay during the rally. This is because bubbles normally arrive there, just before the baseline. When playing, try to keep returning back to mid-court so the opponent can't hit a winner on the other side of the court. Try to aim bubbles on the sides and not in mid-court. This will tire out the fish you are playing against.

It is important to train on court so you are accustomed to the feel of different surfaces. Note that there are different types of courts: Sand courts, which slow down the pace of the bubble, will make the rally long and tiring. Make sure you strengthen your stamina before playing on these courts. Hard court, which is the normal court, will let the bubble bounce, but the bubble will be fast, making rallies short and difficult. You need balance on these courts, for if you fall it might hurt. Despite being squishy, it has a rocky bottom!

Once Upon A Fishbowl

Make sure to keep those fin-aids handy! And finally, Plankton court, which does not let the bubble bounce as easily. The ground is rubbery and has slight grooves to keep the bubble spinning. Smashes and volleys are good for this court! In no time at all, you'll be able to master these courts!

The Scoring System

- On a moving scoreboar, the server's score is stated first and then the receivers.

- If you have 0 points, it is stated as love. For example, 15,-love or love-all.

- First point is called "15", second point "30", third point "40" and the winning point is called Game!

- The first fish to get 6 games will win the round, unless the opponent has 5. If the score is 6-5, the winning fish must get 1 more game. If not, a tiebreaker is played.

- A tiebreaker is the first to 7 points. You must lead by two points to win the tiebreaker.

- In women's Bubble Ball, you must win 2 rounds before the other player. In men's, you must win 3.

Other Bubble Ball Terms

- **Lob:** A shot that goes all the way in the air and then to the baseline, most of the time over someone's head. These are risky, but effective, so make sure you practice them. You need a lot of control for these wild shots to go where you want them to.

- **Drop Shot:** A bubble that just makes it over the net, sometimes intentionally and sometimes not. These are good to play if the opponent is far away but beware; if they make it to the bubble in time, they can play a winner easily!

- **Change-over:** Every odd numbered game, the players get a few minutes of rest time to wipe their faces and drink water, and then they switch sides. Every round, they get 2 whole minutes of rest time, to supply your body with everything it needs!

Now that you're equipped with the basic knowledge of Bubble Ball, you're ready to play! For more advanced players, check out these books:

- Court Kings and Queens - L. P. Swimson

- My Story (a biography) - Whale Seamond

- Tricks for Two (How to Play Doubles like a Pro) - Vanessa and Reilly Weedleaf

There are other books and documentaries listed behind. Remember, the most important thing to do when playing

Once Upon A Fishbowl

Bubble Ball is PRACTICE! Focus on your technique and body build-up. Strength, stamina and endurance will be acquired throughout this process. And, finally, keep a great attitude as soon as you step on court! Smile, keep your chin high and try as hard as you possibly can! Everyone can play Bubble Ball, so long as you have the perfect mindset!

This excerpt was for clarification purposes. I apologize for the cheesiness that this author displays, and the excessive amount of exclamation marks. She makes it sound easy. Try spending three hours on court, dripping with sweat and fatigue and a coach yelling at you to GET THAT SHOT RIGHT! and you'd beg to differ. To play Bubble Ball, you need more than just a great attitude. You need passion.

Cephalopedia

- A Glossary

Cephalopedia - A Glossary

Following is a brief glossary of the marine terms appearing in this book, alongwith their closest counterparts in the human world.

Agarade (Orangeade)
A very nutritious drink made of Agar, red sea-moss and dulse.

Alligatorade (Gatorade)
A sports drink that comes in many flavors and colors.

Althea Gilson (Althea Gibson)
An ocean-famous, blue Bubble Ball Champion, known for being the first blue female fish to win a Grand Clam in Bubble Ball. She was born in 1927 and died in 2003.

Americlam Cup (Ameritech Cup)
A now-defunct Bubble Ball tournament.

Andy Rodfish (Andy Roddick)
A male Bubble Ball player who was former Ocean Number 1 in Bubble Ball. He also trained in the Rick Mackerel Academy.

Anemoneid ("Aeneid", written by Virgil)
An epic poem written by the legendary poet, Urgeel, about Beaneas, the founder of a great shoaldom around Rome. One of the classics of fish literature.

Cephalopedia - A Glossary

Aquacar (Petrol-guzzling, polluting car)
Water-powered, non-polluting, personal vehicles for transportation used by fish around the ocean.

Aquahol (Alcohol)
An addictive drink, typically made out of fermented sea-bed grapes that makes a fish feel warm inside, and after a few swigs, makes it feel like an overconfident but woozy whale. The legal age for drinking this is 21 years in the United Shoals of Americlam.

Beaneas (Aeneas)
The protagonist of the epic poem, "Anemoneid". Also features as a minor character in another epic poem, "Welliad".

Blueseaberries (Blueberry)
A round, blue fruit found typically in the shallows. It falls under the food category of sea berries.

Bobbing Threnody (Robert Kennedy)
A politician from Americlam who also served as the 64th United Shoals Attorney General. He was born in 1925, and was assassinated in 1968 by a Palestenian fish named Sirhan because of Bobbing's support for the Jewish state of Fishrael.

Boodheests (Buddhists, who worship Buddha)
Fish who worship the Mermaid Boodhaa

Cephalopedia - A Glossary

Brine-block (Sunblock / Sunscreen)
A thick cream used to protect fins and tails against the harmful salts in the water. Brine block is also made in the form of a spray.

Burger Kingfisher (Burger King)
A popular fast-food brand that sells gigantic burgers and other fried food. That's typically why so many frys beg their parents to take them there!

Caroline WozniMacki (Caroline Wozniacki)
A renowned Bubble Ball Player who is also one of Selena Gilliams' best friends.

Causeweh (Yahweh)
A Mermaid which the Jewfish believe to be the ultimate Creator.

Clamton (Compton, California)
A region on the western part of United Shoals, in the state of Dolphornia. This was where Selena and Neptuna were brought up as little frys.

Climes magazine ("Time" Magazine)
A weekly fishizine containing articles of topical interest, news, analyses of current events, etc.

Coral Peace Prize (Nobel Peace Prize)
A very prestigious award given to fish who contribute significantly to the advancement of fish achievements.

Cephalopedia - A Glossary

Coyshen (Caishen)
The Mermaid of Prosperity worshipped by the fish in South China Sea. Closely related to the Western Mermaid, "Mammon".

Crab Lincoln (Abraham Lincoln)
The 16th, and arguably the greatest ever president of the United Shoals of Americlam. A fish of immense stature who shepherded the Shoals through a very bloody Civil War in his attempt to completely abolish slavery and establish fully united shoals. He was born in 1809 and was assassinated in 1865 by a kookfish named John Wolffish Boor, who was enraged by Crab Lincoln's fight for voting rights for blue fish.

Crusteans (Christians)
Those who believe in Mermaid Seesus as the son of the one true Almighty.

Danyella Anchovy (Daniela Hantuchová)
An international female Bubble Ball Player.

Democrab (Democrat)
A political party in the United Shoals of Americlam.

Demoiselletieva (Elena Dementieva)
An international female Bubble Ball Player.

Cephalopedia - A Glossary

Disfinfectant (Disinfectant)
An antiseptic gel made of aloe, milfoils, brine-hyacinths and other such medicinal plants to ward off the germs which afflict sea creatures.

Dolphornia (California)
The waters around Overland California.

Fillinoy (Illinois)
One of the state-shoals amongst the 50 state-shoals which comprise the United Shoals of Americlam.

Fin Clijster (Kim Clijsters)
An international female Bubble Ball Player.

Fin-grips (Racquet Grips)
Bandages that help protect fins whilst playing. These can come in various shapes and sizes and allow for better grip on the bubble so it doesn't pop.

Finnings (Earrings)
Intricate pieces of jewelry that fix on to the edges of your fins, nearby to where your head is. These can come in any color, shape, size or material, and are currently a very popular trend between female fish.

Fish-shers (Fissures)
Cracks in the land underground which conduct water.

Cephalopedia - A Glossary

Fishard Gilliams (Richard Williams)
The father and former coach of Neptuna and Selena Gilliams.

Fishigan (Michigan)
The waters around Overland Michigan.

Fishizine (Magazine)
A booklet made of reed-and-moss paper carrying a variety of news, entertainment and thought-provoking articles and images (some even those of the Overland and humans and other land animals).

Fishler (Hitler)
A German fishicidal maniac who was the leader of a particularly virulent group of yellow supremacists in Germanic waters; cause of the Shoalocaust, one of the most evil acts perpetrated against marine creatures.

French Fry Open Sea (French Open)
This is a very prestigious major bubble ball tournament dedicated to young fish ("fry"), played in the seas near Overland France. NOT related to human French fries.

Genus Marlinae Concordia (Concorde airplane)
"A superfast species of fish - not known to humans yet - in the family, "Istiophoridae". Concordia can cruise at speeds up to a hundred miles per hour for hours on end. Their streamlined bodies and length enable them to carry nearly a hundred small fish nestled inside their skin folds and (for first-

class passengers) the uncommon scales."

George Swish (George Bush)
Americlam's 43rd President from the Repelican Party.

Gillnasium (Gymnasium)
A place filled with many exercise equipment for fish to improve their health and keep fit. The best part of gillnasiums is that most are equipped with modern sound speakers, so you can stretch your tail while still bopping to the tune of "*What Does the Fish Say?*".

Grand Clam (Grand Slam)
An achievement where a Bubble Ball player wins all four Open Seas tournaments in the same calendar year. These are the Ospreylian Open Seas, French Fry Open Seas, Wimbleswim and the United Shoals Open Seas (also called US Open Seas.)

Hammer Herring (Homer)
A great poet of ancient times from the waters around Greece.

Hydronet (Internet)
An Oceanwide electronic repository which puts all sorts of sensical and nonsensical information at your fintip.

Indian Shells ("Indian Wells" tennis tournament)
An annual Bubble Ball tournament held in Dolphonia in March.

Cephalopedia - A Glossary

Istiophoridae (Istiophoridae)
A type of fish family which includes the marlin fish.

Javelin Henin (Justine Henin)
A former professional Bubble Ball player.

Jelena Lemon-Tetra (Elena Likhovtseva)
A former professional Bubble Ball player.

JellyGuns (Guns)
A cheap assault weapon which is commonly used in fish gang-wars. It has a trigger mechanism which launches very sharp bullets made of tempered jelly at high speeds to pierce softer objects like fish body. Some types of these bullets are hollow and filled with jellyfish poison, others are designed to cause just brute force damage. There are guns which launch metal and stone bullets, too, but they are more military grade. Jelly is a very cheap substance and jelly-bullets can be mass-produced.

Jewfish (Jewish person, who follows Yahweh)
A fish following Mermaid Causeweh.

Jim Kelp laws (Jim Crow Laws)
A series of discriminatory laws that suppressed blue fish in Americlam. For example, "No blue fish may drink from the water fountains designated for yellow fish and vice versa." While it seems to follow the phrase of Separate but Equal, the punishment doled out to the blue fish were ten times worse than those to the yellow fish.

Cephalopedia - A Glossary

Lake Fishigan (Lake Michigan)
Humans call it Lake Michigan. Tomato, tomaatoe... as our great writer, Trillium Shapesmear, said, "A water lily, by any other name, tastes just as sweet."

Lava Camps (Concentration Camps)
Monstrous places created by oppressive dictator fishes to kill and torture fellow fish. Many of them are located at the vents of underground volcanic fissures from where ultra-hot water bubbles up, roasting unfortunate fish.

Limoray (Limousine)
Long aquacars which cater to rich and/or famous people. These are also used for VIF's (Very Important Fishes) such as politicians and royal figures, as lavish protective measures and status symbols.

Lindsay Divingport (Lindsay Davingport)
A former professional Bubble Ball player.

Mahafish Gandhi (Mahatma Gandhi)
An Indian fish activist striving for the freedom of his shoal and for world peace. He led the Indian Ocean to freedom and independence from the Empire of the Britfish. So great was his contribution to the freedom fight that the Shoal of Indian Ocean calls him the "Father of the Ocean" and has given him the title of "Mahafish" - "Great Soulfish". Gandhi was devoted to the principle of Non-Violence. Born in 1869, he was very tragically assassinated in 1947 by a nutfish named "Nutram Godless".

Cephalopedia - A Glossary

Maria Sharkapova (Maria Sharapova)
An ocean-class Bubble Ball player.

Marlin Fisher King, Jr. (Martin Luther King Junior)
A leading figure of the Civil Rights Movement in the United Shoals, playing a very prominent, pivotal role in the overturning of the segregation laws in the Shoals. He won the Coral Peace Prize in 1964 for his contributions to the upliftment of the blue fish society. He was born in 1929, but was tragically assassinated in 1968 by James Eelray.

Mary Pierce-Tooth (Mary Pierce)
A retired Bubble Ball professional player

Megalophon (Microphone)
A device modeled out of the vocal cavity of the legendary shark, Megaldon. It amplifies fish sounds so large schools of fish can be addressed. There is a bigger amplifier available as well, the Whaleophone used in concerts.

Mermaid (Holy Being (typically termed as "God"))
A mystical being said to be the Creator of the world. There are many different types of Mermaids posited by fish, and the matter about the Mermaid's actual existence is constantly debated.

Monica Seals (Monica Seles)
A retired Bubble Ball player. Did you know she's also in the Interseas Bubble Ball Hall of Fame?

Cephalopedia - A Glossary

Moss-notes; mosspad (Post-It Notes)
Soft writing paper made of moss, with one side made lightly sticky so a fish can make quick notes and pin the note to an object like a refisherator as a reminder.

Musselims (Muslims)
Those who believe in Mermaid Shellah as the one true Almighty.

Obama, Etheostoma (Michelle Obama)
Former First Lady of United Shoals, married to Tosanoides Obama. She was very influential in raising awareness about fry adversity, the need for fish to get a full education, and for girl fish to charge confidently in the ocean. She is a "spangled darter" fish.

Obama, Tosanoides (Barack Obama)
Americlam's 44th President; married to Etheostoma Obama. A Democrab. First blue fish in history to become US President.

OddaSea (Odyssey)
An epic tale of very adventureous fish in Grecian waters called "Oddussus", written by a very articulate Mediterranean fish, Hammer Herring. One of the classics of fish literature.

Ospreylia (Australia)
A large ocean around Overland Australia

Cephalopedia - A Glossary

Ospreylian Open (Australian Open)
Another major Bubbble Ball tournament held in Ospreylia. One of the four tournaments which are part of the "Grand Clam"

Overland (Land)
Landmass outside the ocean on which humans live.

Pear (Apple)
A very large company, the producer of many new-age instruments like MyPod, MyPad and Marlintosh.

Philosofish (Philosopher)
Fish which are given to pondering over issues related to fish ethics, nature of existence, meaing of life and other such metaphysical speculations.

Pufferthorn (Serrated whip)
A fin-held instrument which has an inflatable end laced with puffer-fish spines. It can cause very painful lacerations on skin.

Reefcase (Briefcase)
A compact container made of hardened coral, whaleskin, walrus blubber, etc. to keep together your belongings while moving around.

Refisherator (Refrigerator)
A technological contrapton that chills food and keeps it fresh. Almost every fish's house is stocked with one.

Cephalopedia - A Glossary

Repelican (Republican)
A political party in the United Shoals of Americlam.

Rick Mackerel Academy (Rick Macci Academy)
A prestigious Bubble Ball training Academy which has steered many famous Bubble-Ball faces to success. For example, the Gilliams sisters, Maria Sharapova, Shoal Stephens, and Andy Rodfish.

Roguish Rederer (Roger Federer)
A world champion in professional Bubble Ball; possibly the greatest player ever.

Rosa Sharks (Rosa Parks)
A blue fish activist in the Civil Rights Movement who was responsible for lighting fire to the entire movement with her act of defiance on a bus in the city-shoal of Montgomery. She was born in 1913 and passed away in 2005

Sand Dollar = Sand\$ (Dollar)
The currency used underwater (unlike the Overland, there is only one type of currency in the oceans.)

Sand Fincisco (San Francisco)
The waters surrounding Overland San Fransisco

Seal-fur towel (Cold towel)
Towels woven with seal fur that is collected from the depths of the Arctic Ocean. These are waterproof, but salt absorbent, and are one of the most advanced inventions.

Cephalopedia - A Glossary

They were first made in the waters around Turkey and then spread ocean-wide.

Sealphone (Cell Phone)
A modern technological device which enables fish to speak to one another over long distances.

Searabic (Arabic)
One of the major languages spoken underwater.

Seava (Shiva, one of the Trinty of gods worshipped by Hindus)
A Mermaid whom Heendoo fish worship.

Seaweed (Weed)
Slang for a drug which is inhaled after lighting up in cold, water-resistant flame

Seesus (Jesus)
A Mermaid whom Crusteans worship.

Selena Slam (Serena Slam)
Nickname for winning all 4 consecutive major clams however not in the same year.

Shellah (Allah)
A Mermaid which Musselim fish worship

Shellbourne (Melbourne)
A city-shoal in Ospreylia.

Cephalopedia - A Glossary

Shoal Stephens (Sloane Stephens)
A blue professional Bubble Ball player.

Shoallywood (Hollywood)
The entertainment and movie-making industry in United Shoals of Americlam. Very glitzy, very fake.

Shoalocaust (Holocaust)
A fishicide caused by Fishler and the Nazis that killed over six million Jewfish. This happened during Ocean War 2

Steffi Grayfin (Steffi Graf)
A world renowned former Bubble Ball champion. One of the greatest female players ever.

Stingray Express (Bus Service)
A national Bus Service

Swimover (Walkover)
A term used in Bubble Ball tournament. If a player, for whatever reason, is unable or unwilling to continue with the match, the opponent is declared the winner and given a "swimover" to the next stage of the tournament.

Swimway (Road or Driveway)
It can mean both, a small path in front of a fish-house for the seahorse to get out, and a specific lane in an ocean current for the seahorses to gallop.

Cephalopedia - A Glossary

Tail extensions (Hair Extensions)
Colorful strands of cartilage which attach onto the backs of tails to make them longer & more vibrant. A popular fashion trend amongst teen girls.

Telefishion (Television (TV))
A modern invention where fish can see moving pictures and videos.

The Fishy Board of Welfare (Various Government Welfare Organizations)
A governmental agency responsible for looking after the welfare of the fish community.

Turbunet (Turbulence)
A particular form of turbulence in water caused by scores of waving fishing nets. Very dangerous for marine life so all pilotfish avoid flying the fishplanes close to any turbunet region.

United Shoals of Americlam (United States of America)
A collection of 50 state-shoals and territories of fish in the Western Oceans, held together as One School by a wide variety of concepts - shared history, a Constitution, culture, etc.

Urgeel (Virgil)
A great poet of ancient times from the waters around Rome.

Cephalopedia - A Glossary

Urope (Europe)
Waters around Overland Europe.

US Open Seas (US Open)
United Shoals Open Seas; another major Bubbble Ball tournament. One of the four tournaments which are part of the "Grand Clam".

Welliad (Illiad)
Welliad, also known as "Gilliad" or "The Hum of Gillium" is an ancient Grecian epic poem written by a very articulate Mediterranean fish, Hammer Herring, describing a war and long term seige of the City of Trout (Gillium). This is the book which gave rise to the term, "The Torjan Seahorse". One of the classics of fish literature.

Whaleport (Airport)
The departure and landing place for fish to travel overseas.

Wimbleswim (Wimbledon)
Another major Bubbble Ball tournament held in the waters of English Channel. One of the four tournaments which are part of the "Grand Clam"

Winstone Churcheel (Winston Churchill)
An eel fish who was one of the most prominent Statesman of the 20th century. Prime Minister of the English Channel. Born in 1874, pased away in 1965.

About the Author

In her Utopian world, you would probably find Aria curled up on a plush bean bag, sipping a mint hot chocolate, immersed in a book. Like many children her age, she is inquisitive and reflective, with a very loose leash on her imagination. A book-lover since she was a child, it is her dream to become an accomplished writer someday, and her creativity and flair are portrayed in her poems, stories, artwork and notes. She is often lost in thought, more involved in the world in her head than the one outside, and is constantly jotting down ideas for future projects. Inspired by figures like Malala Yousafzai, Michelle Obama, and Serena Williams, she believes in taking a stand for what she believes in and using the resources that she is privileged to have to help those in need. As her kindergarten self once scribbled:

Three attributes which change the world
Love with its Loyalty
Peace with its Power
And Harmony which is helpful
In every Hour…

Aria wishes to use her writing platform to raise funds for social causes such as providing clean drinking water for school children and girls' education, and raising awareness about the common problems hurting our society.

She is a grade eight student studying at the United World College (Dover) in Singapore. In addition to reading and writing, she paints, plays tennis, learns guitar, and acts in drama productions.